THE AFRICAN LOOKBOOK

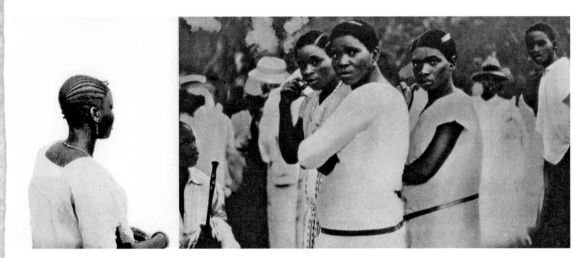

CATHERINE E. MCKINLEY

THE AFRICAN LOOKBOOK

A VISUAL HISTORY OF 100 YEARS OF AFRICAN WOMEN

Introduction by **EDWIDGE DANTICAT**

Foreword by **JACQUELINE WOODSON**

BLOOMSBURY PUBLISHING

NEW YORK · LONDON · OXFORD · NEW DELHI · SYDNEY

BLOOMSBURY PUBLISHING
Bloomsbury Publishing Inc.
1385 Broadway, New York, NY 10018, USA

BLOOMSBURY, BLOOMSBURY PUBLISHING, and the Diana logo
are trademarks of Bloomsbury Publishing Plc

First published in the United States 2021

ISBN: HB: 978-1-62040-353-2; eBook: 978-1-62040-354-9

Library of Congress Cataloging-in-Publication Data is available

2 4 6 8 10 9 7 5 3 1

Designed and typeset by Simon Sullivan

Printed and bound in China by C&C Offset Printing Ltd

To find out more about our authors and books visit
www.bloomsbury.com and sign up for our newsletters.

Bloomsbury books may be purchased for business or promotional use. For
information on bulk purchases please contact Macmillan Corporate and
Premium Sales Department at specialmarkets@macmillan.com.

For Maame Yaa

CONTENTS

While I occasionally refer in these pages to a global Africa—the fifty-four countries that comprise one continent—the fashions and photographies featured are largely of nations of the Sahel (Mali, Burkina Faso, Niger, and Chad) and of what many think of as the African-Atlantic: countries with Atlantic coastlines from Morocco in the northwest to Angola in the southeast, including here Senegal, the Cape Verde Islands, Gambia, Guinea, Sierra Leone, Liberia, Côte d'Ivoire, Ghana, Togo, Benin, Nigeria, Cameroon, Equatorial Guinea, Gabon, the Republic of Congo, and Angola. My focus has been guided by a particular collision of trade and fashion systems, and by the photographers who themselves often established studios along similar routes.

A NOTE ON THE ARTWORK

Woven through this narrative are images by Frida Orupabo, the Oslo-based Norwegian-Nigerian artist also known for her work as nemiepeba. Frida has taken materials from The McKinley Collection and reworked them through her inimitable eye into a series of collages that deepen the way in which we engage the original photos and their histories. It is an enormous privilege to have Frida join me in this project.

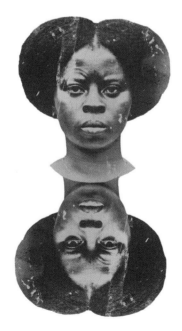

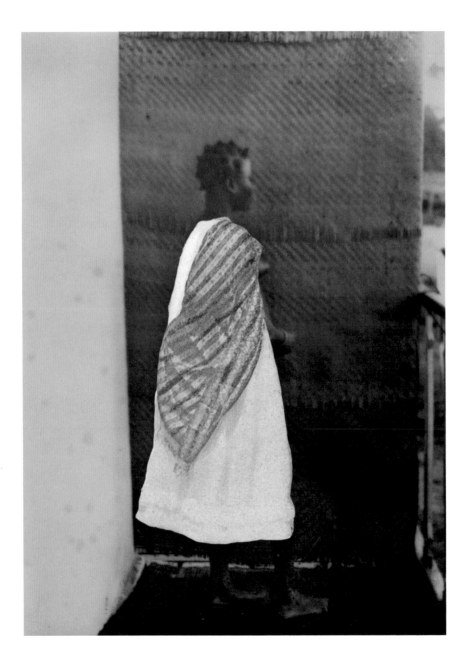

T'S SOMETIMES HARD TO REMEMBER, in this age of endless selfies, how momentous a single photograph can be. As someone whose only childhood photographs from before the age of twelve are studio portraits taken on special occasions, I'm endlessly drawn to such portraits, whose formality and purposeful construction makes them look, to me, like paintings. As with many of the women in this glorious book, both the sewing machine and the camera connected my female relatives near and far. All the dresses I am wearing in my childhood photographs were either sewn for me by my mother, a professional seamstress, or my aunts, who wanted to impress her from a distance after she'd traveled from Haiti to the United States, leaving me in their care at age four.

How lucky we are that Catherine E. McKinley has collected this exquisite series of photographs from many corners of the African continent over the last thirty years, creating, though it is called a lookbook, something more akin to a communal family album. "Look," she is telling us, "I have gathered these images, not just for me, but for you, and also for them, who have reframed and reclaimed the camera as their own."

At the end of the nineteenth century and the beginning of the twentieth, millions of ethnographic and anthropological images of Africans—postcards, cartes de visite, books, and photographic albums—were printed worldwide, coinciding with the golden age of imperialism. Those photographs were meant to be salacious, a type of colonial porn, with Black female bodies presented partly or fully naked. In those images, even ceremonial dress was meant to be titillating, especially when combined with bare breasts. There is documenting, but no such "othering" in the photographs lovingly gathered here. Here we are among women who remind us of members of our family. In many cases the photographs had clearly been planned for and deliberated

over; both the photographer and the photographed seemed to have realized that they were creating heirlooms. In that way the most self-directed of these photographs share much with the "selfies" of today, in that we are possibly seeing exactly what these women want us to see. Before the wide accessibility of cameras, and with sensationalized images of African women being widely distributed, fashioning and crafting an image of one's self was an act of both correction and preservation—proof of the range of beauty and elegance the world was otherwise telling us we could not possess. It was also a rebellion of sorts, not only against colonial exoticism, but also against the drab garb of the ordinary workday.

A few years ago I was traveling with a group of American college students in the southern city of Les Cayes, in Haiti, when one of the students took out her camera in the middle of an outdoor market and started snapping pictures of a street vendor who was napping on several bags of charcoal. Alert to the possibility of new customers, the vendor woke up and found the student taking her picture. I could tell from the look in her eyes that the vendor was using every shred of restraint she possessed to keep from jumping over those charcoal bags and grabbing that camera out of the young woman's hands and smashing it on the ground.

"What makes you think you can just take my picture?" she shouted as her friends nodded in agreement. "Even if I look poor to you, even if I look like I am living in misery, my misery is mine."

We apologized and quickly moved on, but I have always wished that, though we were not professional photographers, we'd asked that lively and energetic woman if we could photograph her in a setting of her choosing. I have always wondered what she might look like in photos that she's consented to, and in pictures where she's showing her favorite parts of herself. Sometimes I think I see her in formal portraits of similar-looking women. At times I thought I spotted her in a few of the images in this book. Would she be half smiling, like the wigged woman looking up from her sewing machine? Or would she almost seem to be embracing the camera while wearing her most luxurious clothing, like so many of the women here?

It's also wonderful to see both famous and anonymous photographers represented here. Bringing together known and unknown creators seems only fair, since in so many cases, we also do not know the women's names. I imagine that these photographs, of individuals or couples and families, were meant to be or were once exhibited in living rooms, bedrooms, or parlors,

or were carefully kept among the pages of books, or in the wallets of lovers or migrant relatives, who longingly looked at them over the course of days, months, years. Whether photographed alone or with others—children, fiancés, sisters, mothers—these women, even when used in postcard images, nude or clothed, visually decry the postage stamps, which tried to turn them into curio. Their beauty remains defiant, though it saddens me that in some of the photographs many of the women copied the European habits of using their servants as props to display their wealth. Still even these types of photographs, like the exotified nudes and partial nudes, offer us a record of the many ways that Black female bodies were presented, both with and without their full cooperation.

The closer we get to the present, though, the more will and individuality we see in these faces, the more pleasure even. These women seem to be enjoying the camera as much as they're enjoying both the foreign and local styles of clothing they are wearing. The photograph, which in many cases they are paying for, is yet another means of self-expression, like their style of dress, hairstyle, and even the cloth-draped backgrounds.

What does it mean to tie your cloth to that of another person, as we learn here about Ghanaian tradition, or to be in full dress? It means, in part, that the cloth is more than covering for the body, just as photographs were once believed to capture more than a person's physical likeness.

"Skin was the original human cloth," McKinley reminds us while inviting us to look at both covered and uncovered Black female skin—rich and textured and sometimes tattooed and ritually marked skin—along with Black female bodies, which have been both indentured and free, both lavishly decorated and plain, but nevertheless, to my eyes, always extravagantly beautiful.

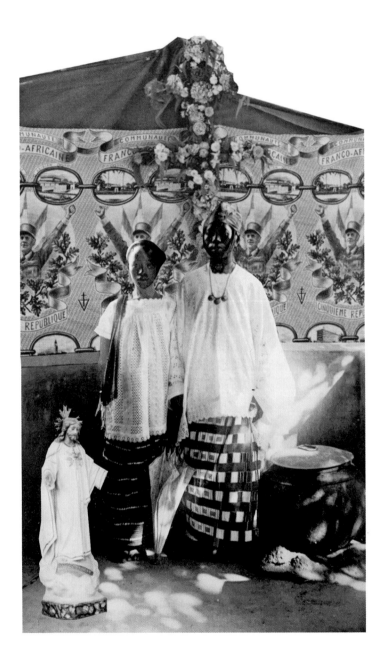

URING THE SUMMER of my seventh year, my mother enrolled my older sister and me in a class at the Singer sewing school in downtown Brooklyn, New York. The class met daily from late morning until late afternoon above a Singer sewing machine shop that also sold patterns and fabric. The class was taught by a woman of Eastern European descent with a heavy accent, and I struggled to understand most of what she said. But her accent, it turned out, was the least of my worries. On that first day, the small grouping of maybe nine or ten Black girls were seated before sewing machines we were not allowed to touch while our teacher deconstructed what felt like the history of the sewing machine back to its nineteenth-century invention. While I longed to get my hands on that machine and see what magic I could create from it, I also longed to be outside, back on my Brooklyn block, where I knew my friends were being allowed to run wild in the July heat. There was no air-conditioning in the cramped classroom and, though not allowed to touch our machines, we worked with patterns (mine a 1970s sizzler set) and fabric (mine yellow flowers printed against pink cotton) we had bought downstairs. We were taught how to pin, cut, dart (I was breastless, thus didn't need these, but envied the girls who did), and baste. Finally, with much guidance from our sewing instructor, we were allowed to use our machines, which was—because I was, as my teacher said, "a terrible sewer"—anticlimactic.

My memory of those years in sewing class was often one filled with a deep shame. For decades after, I rejected sewing fiercely. It felt subservient. It made me think my mother had low expectations for me. It felt too "country," and here I was, a city girl. For a long time, I didn't understand how my mother's desire for my sister and me to have a "skill to fall back on" could

be connected to something older and deeper than that stifling downtown class above a Singer sewing store.

As I slowly moved through the stunningly beautiful pages of *The African Lookbook*, I found myself being transported by the glorious photographs Catherine E. McKinley has collected in a narrative that brings clarity to those summers. As the saying goes, Black people have always traveled with our pain and our medicines. My mother, a Southerner, and I, a child of the Great Migration, trace our roots back to the west coast of Africa. As I pored over the lovely fabrics, the pride on the faces of the women and girls in this book, the adornments that were literally skin deep, I understood again that my long days spent in that classroom were about more than my mom wanting me to learn a trade—whether she knew it or not. Our sewing was and continues to be our pain—and our medicine.

Laced within the beauty of these pages are bits of history and the elliptical and evocative poem-like narrative McKinley uses to describe all that we are seeing—and, by extension, all that we feel.

Last summer, I returned from Ghana with my suitcases loaded down with African fabric. In the years since those Singer sewing classes, I've returned to my sewing machine and have come a long way from pink cotton fabric and sizzler sets. Still, what I am reminded as I again and again pore over the pages in this book is that my mother's dream for me was part of a long line of dreams mothers of the African Diaspora have for their daughters. Dreams that trace themselves back to the continent itself. We took and continue to take the skin, the pain, the fabric, the tools we have. And with all of this—as Catherine E. McKinley has done here—we make something as beautiful as our own selves.

PREFACE BY THE AUTHOR

FOR AFRICAN WOMEN across the continent, many of the most powerful but less remarked upon modern legacies were born of the sewing machine and the camera.

This may seem like a bit of a wild claim: to survey the late nineteenth and twentieth centuries and elevate these two instruments of modernity above the car, above other industry, above medical innovations and the tools of agriculture, above even the machinery of electricity-making and all that it powers. But for decades after the fall of colonial regimes, beginning with Ghana's Independence in 1957, very few of these other things reached democratically or consistently into most African lives, especially women's. And even now they remain elusive, including consistent power or water even in the most state-of-the-art corners of metropolises, whereas the camera and the sewing machine slowly became part of the quotidian—steadfast instruments that offered a powerful means to author one's own life.

This story is best told in photographs, in its own medium. A little more than 150 photographs, gathered from disparate corners. Imperfect documents. No perfect exegesis to be formed. Simply, they hold the story of two colonial machines and the unquantifiable, mostly hidden history-making of the women who were either taken up by these instruments or who took them up, altering, most noticeably, fashion and image, and with them, everything from art to politics, industry, medicine, and the local and world economies. In fact, the very course of the Colonial Project itself.

The Western industrial machinery of sewing was introduced to the African continent in the mid-to-late 1800s, soon after it was officially declared an invention and widely patented in Europe. The first sewing machines to arrive on the continent were kept at trading and bulking stations attached to colonial fortresses. These buildings often housed or had attached to them

small factories that produced garments—primarily uniforms and mission wear—in addition to piece-making and the finishing of cloth, to be dispatched in a widespread and lucrative inter-African trade.

These machines were at first the sole privilege of Europeans and African royal classes. In many African cultures, it is still customary to bury the dead with possessions that represent one's personal and social power—to serve them in their otherworld domain. A nineteenth-century reliquary, placed on the grave of a Mboma regional chief, is revealing of the social value and the hierarchies of early sewing machine culture.

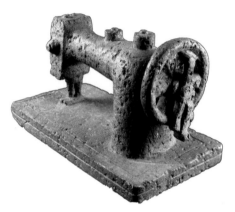

Carved stone sewing machine,
nineteenth century · Dick Beaulieu ·
Mboma, Democratic Republic of Congo

Over time, other African elites acquired machines, and slowly they became democratized (often through missionary education), though still costly, possessions. Hand-sewing was abandoned, innovations in design quickened, and economies widened. The sewing machine became a common dowry item—as essential to the running of a household as to a woman's economic freedom, whether she sewed herself or chose to hire the machine out to local seamstresses.

Today, vintage hand- or pedal-powered machines like the iconic Black Butterfly, which resemble the Congo reliquary, are still reliable staples alongside the latest Japanese or German computerized imports.

The first photography—the daguerreotype—arrived in Egypt in 1840, soon after François Arago's official announcement in 1839 at the French Chamber of Deputies of painter and printmaker Louis Daguerre's invention of the technology. There are similar photo documents of North and sub-Saharan Africa taken very soon after by adventurers. But it would be almost another decade and a half before cameras would arrive in any number in the colonial trade. Once they did, unlike the sewing machine, with its early hierarchy of ownership, cameras were at once taken up by Europeans and Africans alike. Much of the early history of photography in Africa is yet uncovered, but as we map the first known studios, dated from 1853, we learn they are just as often owned by Africans as by European and Lebanese

merchants, and by Black political exiles, expatriates, and returnees from the United States and other nations complicit in the transatlantic trade.

Unknown, c. 1970s · Ghana

For Europe, photography was one of the most effective ways to bind the disparate and far-flung campaigns of Empire. It helped to establish a master narrative of colonial conquest and made the efforts real both to those in Europe and throughout the colonies, where imaginations and morale might falter. Photos were used by colonial governments as a powerful tool of propaganda-making, as a means of reporting, and for European fascination and popular entertainment in the form of stereographs, postcards, cartes de visite, and eventually moving pictures.

In 1869, with cameras in wider circulation, the Colonial Office in London sent instructions to governors worldwide to have all "races" in the British Empire photographed and cataloged to further "science" under the Crown. "Categorize, define, and subjugate" was the mandate. When army engineers were sent with weaponry on expeditions in an African nation's interior, cameramen joined those missions to document infrastructure, missionary projects, and pacification campaigns, as well as to map and survey the land and document who inhabited it. From this practice, the formalization of racist typologies and state-sponsored pseudoscience took deeper root—both of which would have great bearing on twentieth-century societies in Africa

and the West, particularly in how women's lives were administered by the State.

African entrepreneurs often learned photography from individual studio owners, and as colonial government trainees who were eventually employed to work alongside European civil servants. Many eventually opened independent studios, including itinerant ones, crossing national borders and stationing themselves for periods as state documentarians and photographers for a clientele of African elites. In studio spaces and the homes of their clientele they produced images that were often artful—if not masterful—for the intimacies they captured and the display of bourgeois fashions. At the same time, non-Africans catered to more rarified niches of European, African, Creole, and mixed-race clientele, while also creating the endless mire of "everyday" exotica: the mammy figures and "tribal" curiosities; workday typologies; the catalog of breasts from taut to long; the sexually titillating and outright pornographic record that became accepted as still deeply indelible truths by Westerners worldwide.

According to the prevailing art-historical narratives, African women photographers did not emerge until around the Independence era, beginning in 1957 in the Gold Coast, now modern Ghana. Felicia Ewurasi Abban is the first widely documented female studio photographer, learning the trade as a teenager from her father. Later, as owner of Mrs. Felicia Abban's Day and Night Quality Art Studio in Jamestown, Accra, she was part of the official state press corps under Kwame Nkrumah, Africa's first Independence leader. Abban's work was featured in the 2019 Ghana Pavilion at the Venice Biennale. However, buried in academic citations are records of women like Carrie Lumpkin, who set up a photography studio in 1907 in Lagos. The daughter of an elite physician, she was among a community of Saros—formerly enslaved persons who repatriated from Brazil to Nigeria, or their origins in other West African countries beginning in the 1830s. We do not know if Carrie Lumpkin commanded the camera or if the studio was part of her several entrepreneurships, or some blend of the two. It was not until the early 2000s that the art-historical record began to truly recognize African women photographers, who have now grown to a critical mass.

While the history of African women photographers is shrouded, explorations of archives of every kind reveal African women to be the disproportionate subjects of colonial and postcolonial image-making. It is easy to trace in this record what so often is disquieting, vulgar, violent. The photos

assembled here are no doubt part of this wider ceremony of image-making, but they are presented so that our gaze shifts, and the master story begins to fall away. The machinery of the sewing machine and the camera carved out some of the most profound movement in the pursuit of modernity and resistance to colonialism and gender violence. The sewing machine allowed women to wield power, mediate power and usurp and upend the fashion systems driven by colonial powers and African men. The camera followed. In the right hands, it became a place for invention, a vehicle for the work cranked out of the sewing machine and its economy, largely powered by women.

Two decades ago, I began to consciously collect African studio photography. The first images were parting gifts from new friends I met when I first traveled in West Africa in the early 1990s. They were beautiful photos, that much more beloved for the manner in which they were given, with an air of romance and the sweet insouciance of the calling cards we had exchanged for one short moment in grade school in the 1970s, before they seemed to disappear from American culture. As I traveled, I also discovered local photography studios and boxes filled with unclaimed photos on the shelves inside, and became fascinated by the images that still bore the crackly remnants of cassava paste and other homemade glues used to affix them as advertisements on a shop's exterior walls. Studio owners would let me choose from those abandoned photos for a negligible exchange, surprised or somewhat wary of my interest in them. A decade later, I had amassed a small but significant collection, enough to be called an archive. I am not a collector by nature; I felt intimately attached to the photos, as if each person was part of a community, a home I missed. By now, many of the friendships with those pictured have in fact deepened from years of visits, and some places do indeed feel like home. Accra has come to feel like my mother's house: familiar, returning of my love, responsible for raising me up—that is how the city lives in my psyche after nearly thirty years.

The McKinley Collection now features a trove of rare archival, vintage, vernacular, and contemporary images ranging from portraiture to postcards, images in tiny lockets, identity cards, stereographs to cartes de visite. They span the African continent from Morocco to South Africa, Guinea to Kenya, Madagascar to Benin, from 1870—a little more than fifteen years after the very first photographic studios in sub-Saharan Africa are identified—until

now. Including both the masters of the studio—African photographers such as Seydou Keïta (Mali), Malick Sidibé (Mali), James Barnor (Ghana), and others—and many anonymous or lesser known ones, the collection offers, among other things, a framework through which to look forward and backward and investigate an evolution in African women's agency and creative expression.

Trying to read the images in African archives inevitably puts the viewer on a slippery slope. Colonial and African fashion systems—both modern and ancient—mimic each other; sometimes we don't know where "tradition" begins and ends. Once accepted as empirical, evidential, we know that African studio and other photographs were highly constructed in the same way as in the West. Colonial-era photos, with their props and staging and recasting, were a "tool of Empire" that often veered from propagandistic into the absurd. The studio was a place of theater. Sometimes the photograph was only intended for private viewing. Clothing was borrowed from others or from the studio owner, traditions were eschewed for the novelty of a new display of self. Then, we must read through the multiple layers of an image— the fact that colonial studios since their introduction were run by entrepreneurs often tied closely to the state apparatus, with intentions of circulating images abroad.

At the same time, the images, particularly those from African-owned studios, capture the dignity, playfulness, austerity, grandeur, and fantasy-making of African women across centuries—in this way revealing a truly glorious display of everyday beauty.

When we explore early African photographs, especially studio images, both the politics of the body captured in the lens and the details of how the body is displayed (a woman's glance, a button, a tattoo, the folds of a headscarf that signify a complaint or sly wisdom, or a display of true political and economic power in a few yards of cloth), we are privy in these moments to an often coded, subversive history.

The two machines, both late-nineteenth-century agents of colonial Empire, collude to create stunning, as much as sometimes unsettling, visual narratives. What is most often revealed is how deeply cosmopolitan and modernist African women were in their penchant for style, and how they were able to reclaim the tools of colonial oppression to assert selfhood and combat the ways in which their economic livelihoods were threatened. The camera and the sewing machine: the machinery of unquantifiable story-making.

Again, there is no perfect exegesis. Finally liberated from the economy in which the images were created—the long arc of propaganda in support of European imperialism and by the loving yet still heavy weight of the African male gaze—these women are now presented in this volume collectively, yet in no way definitively, representing a hundred-year story of photography on the continent.

As art historian and curator Remi Onabanjo asserts in surveying The McKinley Collection, "You're really getting a full sweep of time and a subversive perspective on how to investigate the history of photography, through its relation tied to black African women as subjects. Doing the work of tracing agency and power relationships, acknowledging the place of black African women inside of these networks, is one of the largest honors one can do."

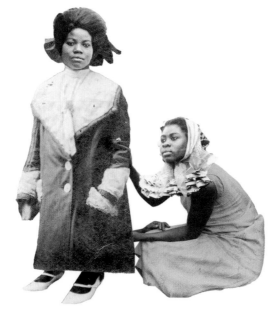

THE AFRICAN LOOKBOOK

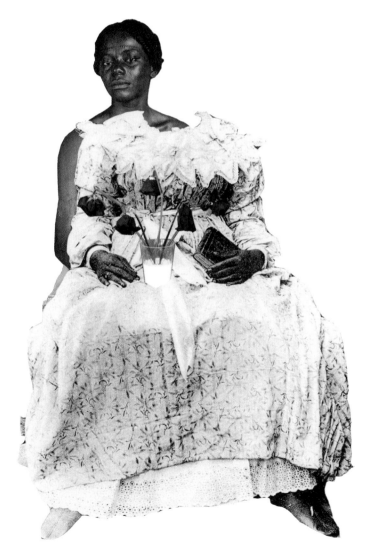

HERITAGE

THE AFRICAN MASTERS, 1900s–1970s

I N 1996, Okwui Enwezor (1963–2019), a Calabar, Nigeria–born curator and a groundbreaking doyen of the international art world, mounted the exhibition *In/sight: African Photographers, 1940 to the Present* at the Guggenheim Museum in Manhattan. The show was responsible for introducing Malian photographer Seydou Keïta (1921/23–2001) to the United States. Alongside the work of other African photographers shooting in diverse modes, Keïta's work shone. For most Western viewers, it was a first encounter with African-authored studio portraiture. Keïta's mastery of the portrait and his mix of relaxed intimacy, depth of tonalities, and layered black-and-white studio decor, plus the very haute, individual, and sometimes whimsical fashions and props sported by his subjects, was unforgettable. Even those whose heritage was on display—who may well have eschewed the idea of the African family album as Western art object—were mostly stunned by the recognition of the familiar and the recasting of it as seminal to a worldview. Suddenly, Keïta was recognized in a way that suggested to the Western art world and other milieus: You've got us and your own selves all wrong. A year later, New York's Gagosian Gallery would show Keïta's portraits in near life-size format, with Keïta, nearing eighty years old, in attendance. In Europe and the United States, the ownership and representation of his works suddenly became high-stakes and both the scramble for and suppression of other African masters began, sometimes within the same stable of arbiters and agents. Keïta's colleague in Bamako, Malick Sidibé (1935–2016), would shortly after rise to a similarly never-before-met international fame.

The women of Keïta and Sidibé's portraits, and those in the work of their peers, seem to have the power to undo all that has been inscribed in the colonial lens. What have these female sitters authored—both with their

highly intentional displays of fashions and, far more poignantly, with what they communicate in that brief moment of a glance that triggers the shutter's snap?

The photos here, by some of the most celebrated photographers of the era—including Sidibé and Keïta—and by those who remain anonymous in posthumous celebration, were commissioned by the sitter or a family member or friend. Sometimes the women would have been invited or pulled into a studio, the photographer well known to the community if not the city at large. The photos were hung and enjoyed at home; in Senegal, in particular, portraiture was an important part of display and was often even borrowed from extended family to be featured in social rites. Many sitters are seen posing at home with an elegant family gallery behind them. Formal photo-taking to memorialize the company one kept or one's dressing for "occasions"—the regular rotation of weddings and engagements, baby-naming ceremonies and parties, and on Christian and Muslim holidays—was considered part of the ritual of the day. The photos were often produced in multiples and would be given as gifts to loved ones, or presented to the families of suitors as part of marriage bids. As the postcard became in vogue, some images inevitably—whether or not with the sitter's permission—made their way into the commercial trade, where they were circulated well beyond national or continental borders.

• • •

Nineteenth- and twentieth-century African cities, particularly along the Atlantic coast, such as Lomé, Dakar, Lagos, Abidjan, and more interior trade capitals like Kinshasa and Bamako, offered a dazzling array of luxury, specialty, and workaday fabrics that were both locally produced and imported from other African markets, Europe, and Asia. Dressmakers there boasted competition as cutthroat as the ateliers of elite international fashion houses.

Cloth has a long history as currency in Africa. As early as the fourteenth century, according to Arabic sources, cotton had circulated widely as currency in West Africa. In the ancient trans-Saharan trade, camels saddled with wheels of stripwoven cotton the expanse of their abdomens and the value of gold, plied the trade routes. In the colonial trade, cloth was a literal stand-in for colonial and African currencies. The 1749 registers of the Dutch West India Company—the largest colonial trade concern for Africa and largest agent in the slave trade for the Americas—record a healthy male slave purchased in the Gold Coast was worth six ounces of gold, payable in equiva-

lent goods, such as a length of cotton cloth. Historians have asserted that cloth was a more effective weapon than the gun in colonial domination. It was a source of huge revenue and a powerful means of subjugation. Cloth imports certainly outpaced those of arms, representing more than 50 percent of commodities sent to places like the Gold Coast, one of the largest hubs for the transatlantic slave trade and trade in other items like gold and salt through the twentieth century. This history is very much alive in contemporary African economies. In West African cities cloth is still customarily sold in six- or twelve-yard lengths with stable values, while other goods rocket and plunge; weavers supply customers with strips from the loom at the measures of old currency, in the same neat rolls the camels toted; and dressmakers and tailors avoid cutting the fabric, or cut and design with attention to the fact that clothing from fabrics with "traditional value" are ultimately part of one's social and financial wealth and security.

West Africans imported textiles from Asia, Europe, and the Middle East as far back as the routes to Timbuktu. Long before the coastal trade with Europe, there was a well-established desire, even a preference, for imported cloths. Unraveling and reweaving textiles was not uncommon. Textiles brought back from hajj, even fragments and linings, appear in the earliest West African clothing. For women, cloth is also one of the most meaningful ways to trace financial independence, particularly one free of men's privy. Women's trade in cloth was extremely lucrative; from one culture, one country to the next, complex systems were formed giving women and men particular dominions over weaving, dyeing, and trade. In this way, women ensured autonomy. Family history was encoded in the cloths; cultural capital was encoded as well. The art of dress was exacting. Cloth served as a literal commentary on family and social events, a prestige record, a communication with the ancestors.

A DANGLING PEARL EARRING, a heavy silver vertebral choker and bracelet that appear delicate on the sitter's illuminated skin. A Euro-style dress sewn from imported taffeta with a European trim at the edge of the sleeve. A Dutch manufactured headscarf, tied in a style named de Gaulle after the French president, by Senegalese and Malian women: a tribute to the Francophone African soldiers on segregated World War II tours in Europe. (Repatriated at the end of the war to places like legendary Camp Thiaroye, a bleak French military outpost on the outskirts of Dakar, to await payment of their salaries, three hundred of these men would be massacred in 1944 after protesting months of withheld wages and their increasingly apparent internment, deepening the intended salute to heroes and complicating the regard of de Gaulle.) In Keïta's studio, black-and-white prints were prominent in the fashions and textiles laid on floors and hung as backdrops. The codes and symbology of the cloths, like the black-and-white stripes of this sitter's dress, evoke the Koran, the infinity of God. They mimic the architectural designs and complex patterning of the mosque and invoke spiritual measures of beauty, lest one become fixated on the beauty of the earthly sitter.

Despite the consummate art of his photos—a painterly, layered, glamorous aesthetic—Keïta saw himself as a stylist more than an artist. Sitters came to Keïta to be staged; to be made, through his photography, middle class. Or, if they were in fact middle class, they came to be made to look even more like the bourgeoisie: modern as defined by the "colons," with the objects and symbols of modernity—a borrowed necklace, a fancy radio, a bicycle, glasses, items which Keïta kept in store for those emptyhanded—or just an added air of leisure.

Modernity could live in the eye as much as in imported luxury: in a relaxed pose, a self-possession, and a certain court of the lens.

Untitled, 1952, 2001
Seydou Keïta · Mali

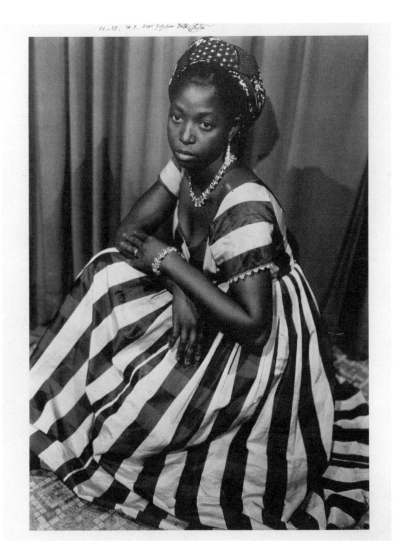

POSING NEAR THE DAWN of Mali's Independence in 1960, there is a perfection to their adornment. An iconic Java print cloth—produced for the West African market in a Dutch factory called Vlisco and created from the design remnants of a failed trade with Indonesia of industrialized Indonesian batiks. The journey of the print from Holland to Indonesia to the African coast in the 1800s is a story wrought in the ironwork initials of Vlisco's progenitor, beside those of King William, in the gate to the Governor's quarters of Elmina slave fort in Ghana. A dress sewn with lace from France or Belgium by way of Genoese artisans. The dresses styled with "Grand Dakar" sleeves. Both fabrics tell complicated stories of European manufacturing for the African markets. A bicone gold pendant necklace, Tukulor gold chokers, and rare carnelian, which dates back to the eleventh-century trans-Sahara trade (an Indian extract, shaped in lapidary workshops in Germany). European watches. Things Portuguese, things Sahelian. Part of dowries, signifiers of status and belonging. Hair threaded into a style called Versailles and covered with taffeta scarves that are tied de Gaulle–style, worn in endless reiterations to assert individuality, status, wisdom, and opinions. The years just before and after Independence were a time of great change. The studio Keïta made would soon be seen as conservative and artificial. His elegant sitters would be called out by their children for their love of Europe and the trappings of the colonial regime. The Pretenders, they were called, by a generation that would trade that elegance for the best of European and American pop culture: James Brown, Jimi Hendrix, hot pants, and cowboys Africanized.

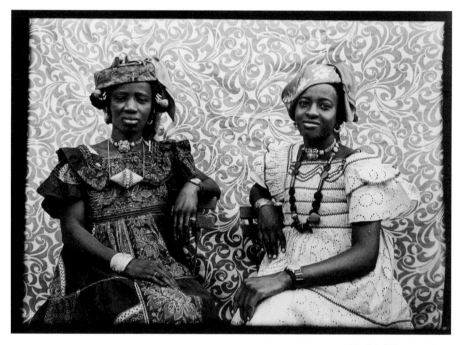

Untitled #460, 1956–57
Seydou Keïta · Mali

Barthelely Koné was a colleague of Keïta and Sidibé and the father of Mamadou Koné, who also became a notable photographer. The intimacy in this photo—the way the child rests on the mother's lap; the feeling that her jewelry and dresses are a grown woman's possessions, loaned in a ritualistic way. With Koné, they were offering a story of inheritance. She's been given the heavily coded gifts of passage into puberty: permission to wear a mature woman's hairstyle she has not quite grown into.

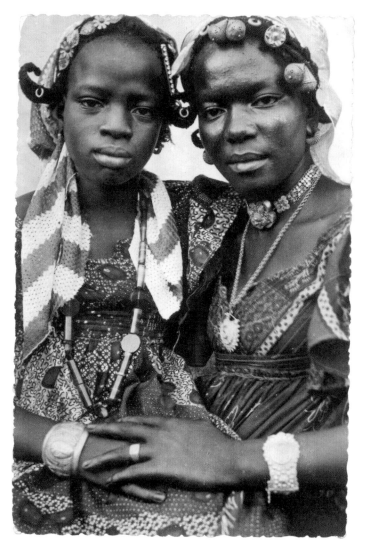

Untitled, c. 1950s
Barthelely Koné (?) · Mali

YÉ-YÉ MUSIC of early 1960s France, inspired by American pop, had wide international reach. It became a rage in Francophone African nations like Mali. The young women's presentation is as much one of up-to-the-minute cosmopolitanism as of optimism and cool, innocence and tumult. Just five years after Independence, Mali's youth were challenging the political tenets of new nation-building. Clothing and music would carry the revolt, and women were striking rebels, wearing edgy styles tailored at home or ordered from foreign catalogs, mixed with African wax-print skirts or wrappers and Afros inspired by U.S. political and pop culture and news of protest. All were considered haram, or forbidden—and not beautiful. Keïta had eschewed miniskirts, Afros, and women in pants. But a new era of photography— looser and outside the confines of the studio—was being ushered in.

Abdourahmane Sakaly captured its spirit in the arena of the studio. Born in 1926 in Saint-Louis, Senegal, Sakaly hailed from a Moroccan merchant family. Introduced to the camera by one of the celebrated elders of Senegalese photography, Meïssa Gaye (1892–1982), he moved to Bamako as a young man, married a Malian woman, and raised a family as he ran a studio alongside one of West Africa's largest markets through the 1970s.

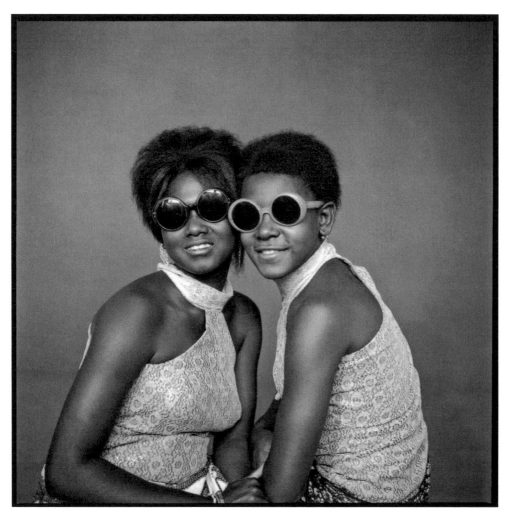

Two Young Yé-Yé Girls with Sunglasses, 1965
Abdourahmane Sakaly · Mali

SISTER EVA IS A "BEEN-TO"—that fabled class who traveled abroad. Still, she knows the importance of requisite gold and having a well-dressed head. Neat hair, hair of good architecture, is more than aesthetics. It is a sign of an intrinsic balance, a soul intact, a firm hold on one's destiny. And as mod as her hair is, it resembles the sleek, molded constructions of the woman at home, like Fanti women's sculpted *tekua* hairstyles when they turn out for customary affairs. James Barnor ran Ever Young Studio in Jamestown, Accra's original city center and the home of many of the most important Ghanaian photo studios of the early 1900s through the 1980s. Barnor would later be the first to bring color processing via AGFA to Ghana.

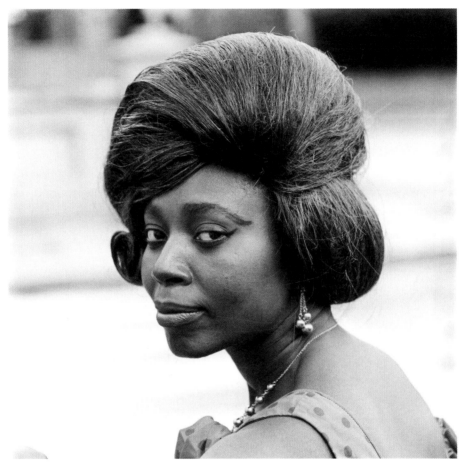

Eva, London, c. 1960s
James Barnor · Ghana/UK

MALI'S POST-INDEPENDENCE SOCIALIST military government created special forces in 1968 to police the behavior of the young, hoping to keep them aligned with State ideas resurrecting "traditional values" lost to colonial imposition. Curfews were established and wearers of short skirts, Afros, and bell-bottoms were sent to reeducation camps, where heads were shaved and dress codes respectful of Islamic religious law were enforced.

In her home-sewn dress, Western but with African bones, head uncovered, past-curfew on New Year's Eve (a non-Muslim holiday, a colonial holiday), this sitter exudes pleasure. There are many stories of Mali's youth smuggling "hot" clothes out of the house under approved clothes. Sidibé was one of the few to depart the studio and follow the youth who had turned to rock and roll and soul music, fantasy play and style impersonations of "American Indians" and Hollywood heroes and heroines. This behavior was read as mindlessness, as a dangerous turning away from values that Independence and liberation movements had sacrificed everything to reclaim. Neocolonialism? What looked to many like offense was a claim at containing all of the violence and the contradictions of decades of turbulence—a stake at shedding identities and codes of "tribe," of Islam, Christianity, and nation, to live in an interstitial place of a new kind of fantasy-born but undeniably African freedom.

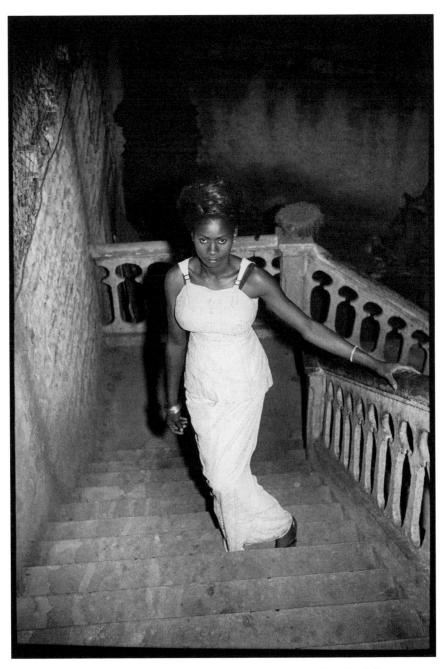

New Year's Eve, 1969, 2011
Malick Sidibé · Mali

SIDIBÉ WAS UNIQUE in his capturing of outsiders of many kinds, and revealing their belonging on their own terms. A Fulani, or Peulh, woman a long way from Niger, and farther even from the Bororo regions of the deep Sahel, sits for him in an African wax cloth tied fashionably like a halter, an age-old village style of workday dress, with a strong, open gaze and soft smile. She is a stranger in the city, a nomad woman who would not easily be comfortable there. Her heavy earrings and tattooed face reveal that she is a visitor from the hinterland known to the caravans who laid the routes that crossed into Europe and the Silk Roads hosting centuries of banditry and jihadist incursions. Outsiders may bring suspicion to the streets of Bamako. But she meets Sidibé in the lens and is rendered an ordinary Bamakoise, quite at home in herself.

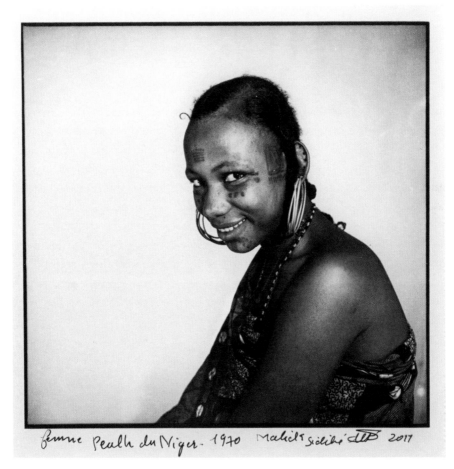

femme Peulh du Niger. 1970 *Malick Sidibé* 2017

Peulh Woman from Niger, 1970
Malick Sidibé · Mali

A WOMAN IN A BOUBOU sewn from costly devoré, a French fabric that had become popular by the 1920s, sits before a heavy silken curtain. *Dirianke*, or Senegalese "ladies with heavy bracelets," are women of status, beauty, and a full, well-perfumed body. Dramatically shaped eyebrows and gums tattooed black to accentuate a full mouth and the whiteness of the teeth—part of a painful test of womanhood—are signs that they have been carefully schooled in the art of dress and seduction. Styling themselves after the fabled *lingueres*, the elites, and *gourmettes*, the Christian-convert mistresses who achieved entry to the colonial upper echelons, they used the art of dressing as a fortress. Rituals of public promenading to show off one's corpulent sensuality and wealth in clothing, and the glamour captured within the studio, were important to their ability to levy social power.

Salla Casset (1910–1974) ran Senegal Photo, a celebrated Dakar studio. The younger brother of Mama Casset (1908–1992), owner of African Photo, who became part of the rarefied few recognized nearly a century later by the Western art world after the promotion of his work by African intellectuals and curators in France, Salla diverged from traditional studio work to the documenting of Senegal's postcolonial political elite.

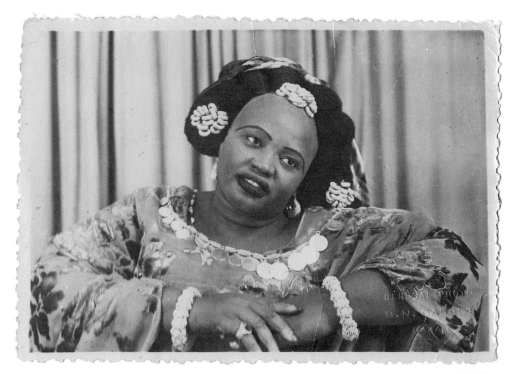

Untitled
S. N. Casset, Senegal Photo, Dakar · Senegal

SIMPLY DRESSED BUT ELEGANT Saint-Louisians, these women appear in a series of iconic photos well remembered by those who have seen the rare images displayed or published. Together they tell an unusual story of Saint-Louis, the former colonial capital of French West Africa, now Senegal, and Mauritania. Legendary for its wealth, which was spread among Africans and Europeans, a mixed-race elite, and others, the city was marked by sophistication and grandeur, and by fashion. Saint-Louis was renowned for the legends of Wolof women who had gained power and status in trade and as courtesans of French colonial officers, traders, and military men.

These photos offer a different fable. The family seemed to prefer the home over the studio. One sitter, pictured in a room of photographs, gives rare insight into the lives of a civil servant class. Flowers, photos, good European furniture. Photography was an expression of fashionable living. The women wear classic *boubou*s. The age of the car in one photo, and their relatively modest dress, show the austerity creeping into a still-prosperous city during the early years of World War II.

We do not know the author of these photographs, carefully preserved by Aladji Adama Sylla. Born in 1934 in Saint-Louis, Sylla worked at the Musée de la Mer on Gorée Island off of Dakar. He worked for much of his life as a curator and museum conservator, while running a popular studio in Guel N'Dar in Saint-Louis where he early on departed from studio work to paint. An irrepressible collector with an internationally recognized archive, Sylla has preserved the works of his peers and little-known studios from the 1930s onward.

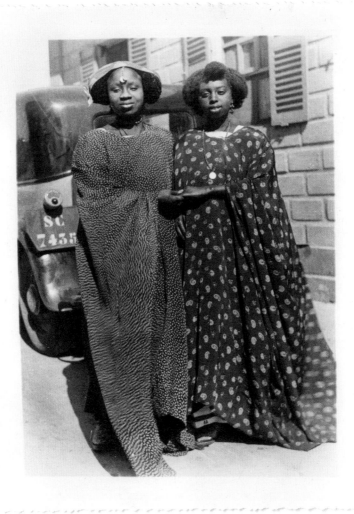

Untitled, 1939–45
Unknown photographer from the Collection of
Aladji Adama Sylla · Saint-Louis, Senegal

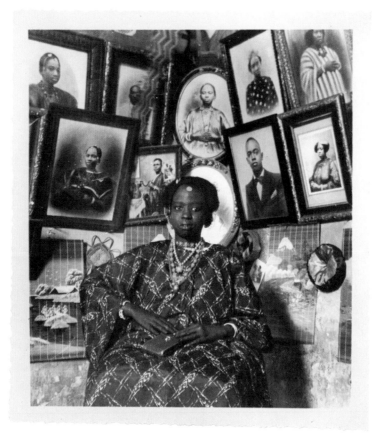

Untitled, c. 1930
Unknown photographer from the Collection of
Aladji Adama Sylla · Saint-Louis, Senegal

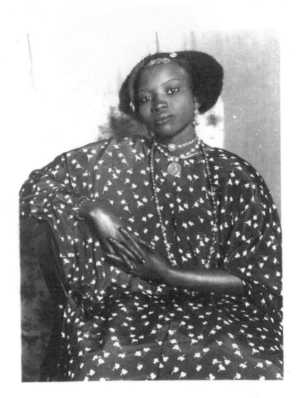

Untitled, undated
Unknown photographer from the Collection of
Aladji Adama Sylla · Saint-Louis, Senegal

BY THE 1950s, as the winds, if not the full articulation of Independence, began to be felt, Dakaroise glamour was changing. With World War II and postwar austerity, there was some shedding of ornamentation, and the traces of de Gaulle–era opulence. A modernist feel of the times emerged among some elites that then carried into the next decade.

Mama Casset, brother of Salla Casset, studied as a teenager in the 1920s with French photographer Oscar Lataque and later with the legendary Tennequins before opening his own studio. He left behind a brilliant catalog of Senegal's high society, cast in dreamy light and shadows and an elegance that only his studio and a few others seemed privy to.

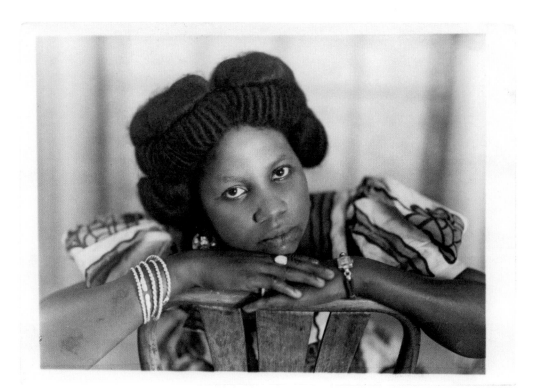

Untitled, 1952
Unknown · Senegal

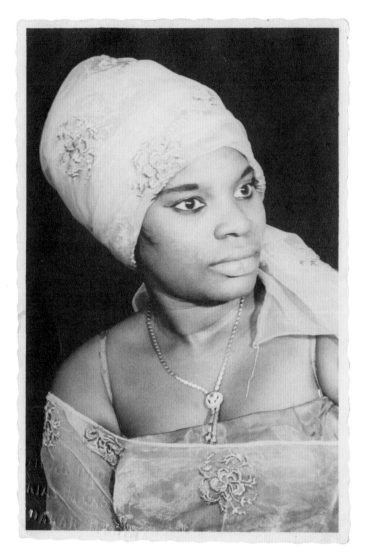

Untitled, c. 1960
Mama Casset/African Photo · Senegal

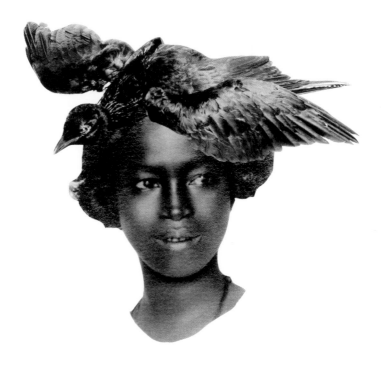

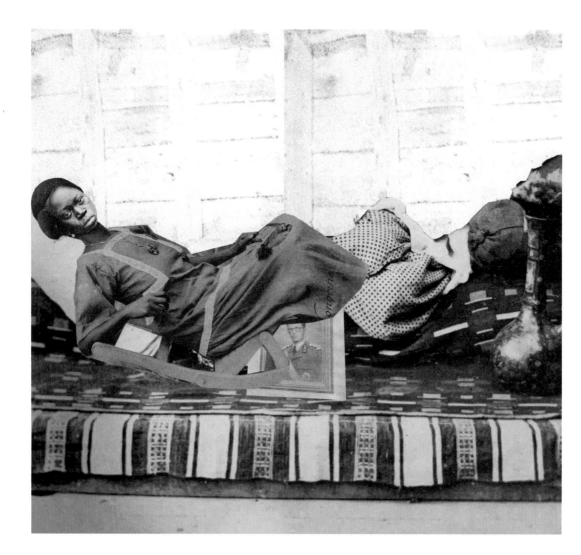

CHAPTER II
WITH A CERTAIN EYE
THE COLONIAL STUDIO, 1870–1957

C OLONIAL STUDIO" is a bit of a misnomer; it might be better to understand the term as a kind of shorthand. "Colonial" is context: the long, sweeping arc of propaganda-making through images in service of European imperialist projects. The machinery of image-making was a colonial enterprise, and no photography could be wholly extracted from that economy. When you make a map of the earliest studios in any African metropolis you will find entrepreneurs and artists of a truly hybrid and often cosmopolitan bent: Europeans; Lebanese and Arab and Asian merchants; African locals and African journeymen; African American, Caribbean, and Brazilian travelers, including the formerly enslaved or their children and grandchildren. Still, the modes and tropes of picture-making—who got trained and how, the language of the studio, the props and apparatus, the identity of sitters, and how and where images traveled—were enmeshed in colonialism.

The colonial studio—African and European and other—was a complex collision of power and agency, beauty, and the tragic and abhorrent. In European studios spanning the 1860s to 1970s, images of African women existed as a preponderance of exotica in "women's work"—women nursing children, pounding food with mortar and pestle, selling on the street, carrying water, or posing in front of the "primitive" home. Cameras fixated on breasts and hair, on body cicatrization, and the suggestive and even pornographic possibilities of rites of puberty, polygamy, and lightly disguised prostitution.

Many African photographers working at the same time would engage these tropes, as would later eras of African photographers (1950s–present), revisiting the images of a woman's back or skin or hairstyle but in a way that,

however much a male gaze still mediated, the colonial gaze was removed. These images could be artful in particular ways, admiring, or honorific, sometimes simply with a palpable detachment as the photographer catered to commerce.

The gaze—that moment when the sitter meets the lens with the intent to author, or perhaps where coercion, or capitulation, or shyness or some other feeling is revealed—is what we look to for a countering narrative to the photographer's, or for assurance that the sitter still has the last word. And then there is fashion. The clothing of the era was always changing, and often it was part of the mythology or manipulation of colonial encounters. But as we read the photographs—read the codedness of eyes and dress—the sitters are freed a bit, and their agency unburdened.

DUNAU

THERE IS VERY LITTLE KNOWN about the photographer Dunau. Even his name is uncertain, difficult to decipher though his signature appears on each photograph. But then there is the surprise of his own image, framed as his sitters are, with earth packed hard under their feet. On the left? On the right? is Dunau, with an unidentified man. Both in colonial uniform, with helmets at their feet. What is remarkable is the contrast of this man and his partner with the other images, printed in Paris onto postcards by the Lumière Society. Taken in 1900 in Senegal, this series is among those from the first of the new century. Women and their loved ones pose in stately manners, mostly seated, always centered in the lens. The stillness and power with which they held themselves is so palpable it feels as alive as the sitter. It is like seeing the early template for photography that will reach across the next fifty to seventy years. It is that form that becomes de rigueur across the ages: the same postures, the same hands, knees spread, feet fanned out. A similar repertoire of dressing. In each photo is it a new negotiation of display between the sitter and the camera, resulting in the same articulation of power?

Whenever and however the Victorian form emerges in Africa, it comes in a very wide, usually shapeless dress with smocking or lace or ruffles. Three of the women pictured here are Muslim or traditionalist. Most of these women wear the "uniform" of Catholicism in Senegal, which was introduced in mission compounds and slowly became indigenized with bits of elegance that define Senegalese fashion, an art of dressing for others, a complex web of sartorial communications that guide women's social community and economic relationships.

Dunau's photos, though somewhat quotidian, are still unusual. The notes he's written on them remark on the goodness and beauty of the women and their families, and the feelings between them. There is an expansiveness in these images that Dunau authored with them.

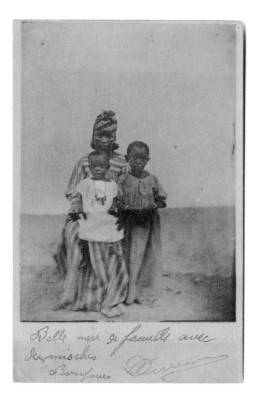

Belle mère de famille avec
marmachos
Bonjours Duvau

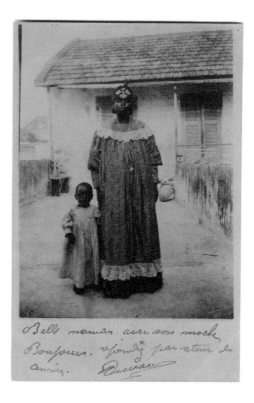

Belle maman avec son mioche
Bonjours, répondé par retour du
courier. Duvau

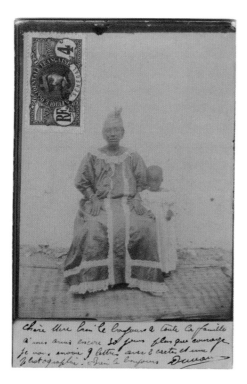

Chère Mère bien le bonjours à toute la famille
à mes amis encore 20 jours plus que courage
je vous envoie 9 lettres avec 2 cartes et une
photographie. Bien le bonjours Duvau

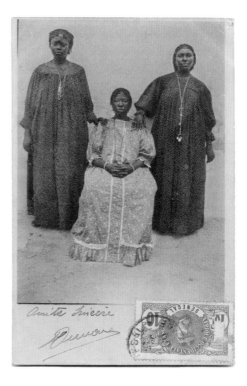

Amitié Sincère
Duvau

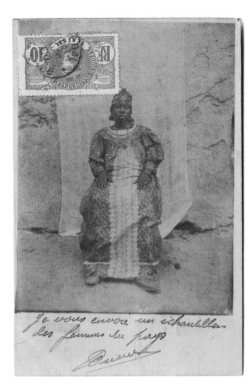

Je vous envoie un échantillon
des femmes du pays
Duval

Beau couple, l'air d'allure
ne manque de rien
Bonjour à tout le monde

Européens vous ne manquez
pas d'allure. Bonjour
30 jours
Duval

Voici le meilleur de mes camarades nous
sommes comme deux frères un souvenir
Bonjour
Duval

INDIGO: CONAKRY, SAINT-LOUIS, AND DAKAR BLUES

THE DAKAR AND SAINT-LOUIS, Senegal, and Conakry, Guinea, studios of the 1860s through the early 1900s are some of the oldest and most distinguished on the continent for their elegance and the art of their backdrops. It is thought that the first Daguerreian studio in West Africa was opened in Saint-Louis in 1860, by Augustus Washington (1820–1875), a Trenton, New Jersey–born son of a mother of South Asian descent and a father who was a former slave and an abolitionist. Known as one of the foremost American masters of the art, he emigrated to Sierra Leone in 1853 believing that it was the only answer to freedom from U.S. racism. He later traveled to other cities along the African-Atlantic coast, settling for a time in Senegal. Washington's story represents the striving, the artistry, and the uncommon worldviews that created the culture of photo studios in those cities. By the early 1900s, picture-taking was de rigueur for many, and there was choice between highly productive studios with differing aesthetics and clientele. For all but the colonial elite and wealthy Guineans and Senegalese not limited in their choices, the question of who would take that photo was often part of the aspirational social story of those capital cities despite colonial impositions.

One other striking thing that set the studios in Senegal and Guinea apart, though the images are all black-and-white, is the display of indigo. Both countries were renowned along the African-Atlantic coast and into the Sahel for their indigo production, historically tied to the ancient trans-Saharan trade of precious "blue gold" into Europe.

There was a long and well-established desire, even preference, for imported cloths in most African cultures long before the coastal trade with Europe began in the 1400s. Asian textiles in particular, as early as the fourth century A.D., were imported by Africans who traded amidst cutthroat competition for specialty markets, moving the cloth across the African continent by boat and caravan, and an elaborate system of head porters. Highly sought-after textiles were also fashioned from the rewoven threads of painstakingly disassembled foreign cloths. All the while, however, African indigos remained one of the most financially and culturally valuable commodities.

Indigo was used in textile production and for complementary beauty: as eye makeup and hair dye, as a body paint, for tattooing, or rubbed into fresh cuts to enhance scarification. Among the noble classes in some countries, it was worn as a paste in the hair or on the skin. And it was used as a stimulant

in the sexual arts, in which cloth and adornment played an enormous role. In many cultures, indigo cloths would be given at birth or as part of puberty rites or marriage ceremonies, and the cloth would be passed down to one's children as a valuable heirloom if not used as one's burial shroud. Indigo in most cultures, with its mysterious aliveness and ever-changing depths, was regarded as an exemplifier of God or Allah or indigenous gods and goddesses, and the infinite path to the heavens. Its use and personal value signified lineage and belonging. Indigo was among the commodities, along with cotton, sugar, salt, and gold, that fueled European colonial empires and especially the trade in chattel slaves. It compounded the extraordinary wealth and power of precolonial African empires, and in many societies, West African women in particular wielded great social, political, and cosmological power as master dyers and indigo cloth and dye traders. Women's indigo power was the cornerstone of ancient empires and twentieth-century anticolonial movements in West African history.

In the Dakar and Saint-Louis studios, among the Wolof majority, women through the 1930s primarily wore an indigo cloth to be photographed that became emblematic of prestige. The cloth's origins are in the *pano d'obra* cloths of Cape Verde, an archipelago of islands off of Senegal's coast that had been uninhabited until Portuguese merchants colonized the islands in the fifteenth century. Cape Verde was an important commercial hub by the 1600s—a transit point for the enslaved and other commodities bound for Europe and the transatlantic colonies. The Portuguese established cotton and indigo plantations there to supply workshops where skilled Senegalese and other weavers and dyers who spun, wove, and dyed *panos* and other cloths for European markets under merchant supervision. Eventually Japanese textile artisans were brought to the islands. The cloths, with their elaborate patternings—which by the late 1800s reflected centuries of Wolof, Mande, Iberian, Japanese, and Islamic influences—were eventually replicated on European cottons and damasks cut into strips that imitated the tradition of joined stripweave, and then stitched as a resist to create similar patterning before they were dyed in indigo.

In one photo, a family of Muslim nobles resplendent in indigo is captured with small mixed-race girls in European dresses. The photo seems to capture the legacy of interracial unions and how both African and European traders who had the advantage of access to both local African commercial networks and colonial know-how and resources through these unions often domi-

nated the trade. Well-connected, shrewd African merchants made huge profits with their knowledge of where and what was desired along the huge expanse of the Atlantic coast and into the interior; their aggressive trading and changing report of demands kept Europeans scrambling; marriage was one means to establish mutuality.

In another elegant portrait of a wealthy Wolof trader's wife, her head-to-toe very finely patterned and dark dyed indigo is the ultimate marker of her status. The irony is that despite the caption of this image, recreated as a postcard, women photographed in this way were usually at least as powerful as their elite husbands, especially adept at trade and owning their own wealth.

In the Guinea studios we see renowned "Guinea indigo"—dyed in deep blues near to black with brilliant white resist patterns. The sitters also wear a glorious range of indigo clothes from Côte d'Ivoire, Haute Volta (Upper Volta/Burkina Faso), and Mali: examples of cloths that for more than four hundred years were exchanged for gold and ivory and slaves from the Gabon estuary to Angola to São Tomé, the West Indies, and Brazil. And with these cloths, tied as skirts or worn as shawls, is a mix of Western missionary-inspired blouses and *boubou*s and Muslim tunics in velvets and lace and cottons, with chintz and taffeta headscarves.

In the photographer's studio, the display of one's beauty and wealth and a discerning taste in cloth was the desire. The hope was that the camera would capture it all so closely that the viewer might catch the treacly but not disagreeable plant, urine, and ash scent of the sitter's indigo and sweet, wafting *thiouraye*, as it's known to the Senegalese, a personal scent burned in one's house and, as the wearer stands over where it burns, perfumes the clothing and thighs.

They display the art of dressing for the studios of some of the most renowned colonial photographers: A. Albaret, Alphonse or A. James, and Francois-Edmond Fortier—and for the studio of other unknown photographers, including an African photographer whose work was collected by the celebrated Senegalese artist and archivist Aladji Adama Sylla.

Untitled, undated
Unknown · Unknown

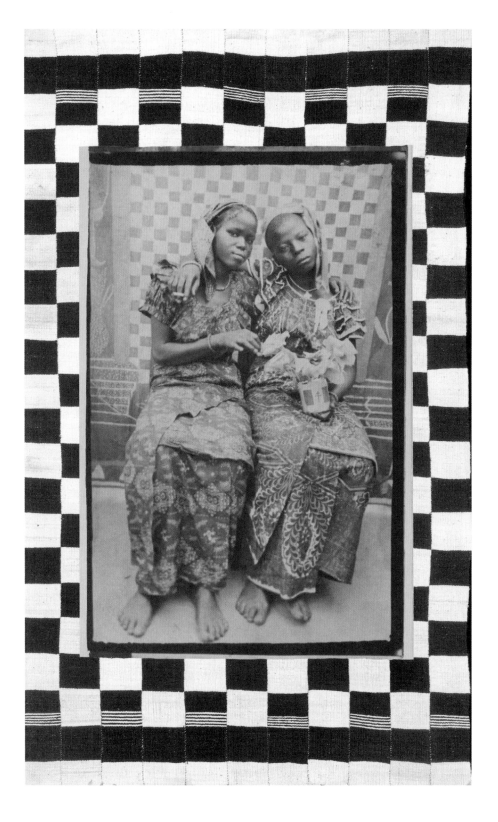

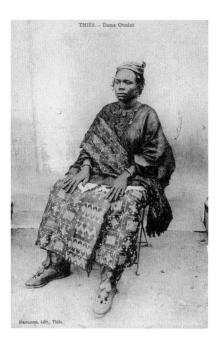

THIÈS. – Dame Ouolof

Hartmann, édit., Thiès

19. A NIORO (Soudan)

Déposé

Une femme d'un traitant ouolofen

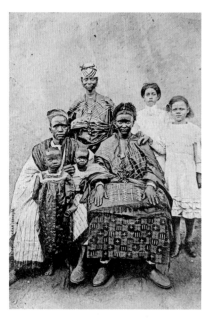

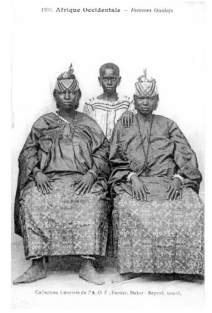

1303. Afrique Occidentale — Femmes Ouolofs

Collection Générale de l'A. O. F., Fortier, Dakar - Reprod. interd.

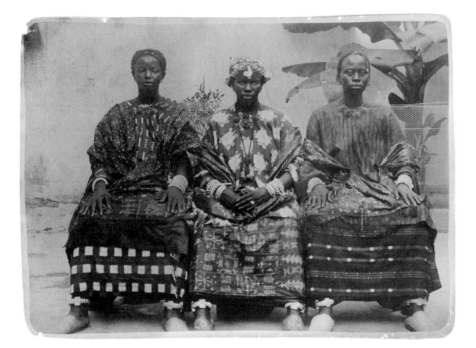

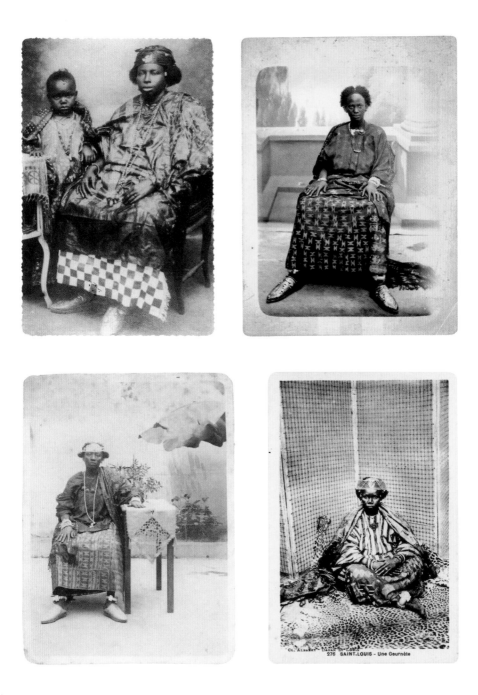

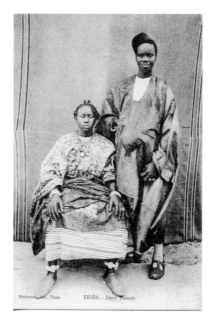

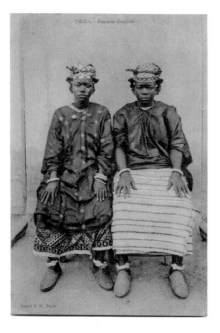

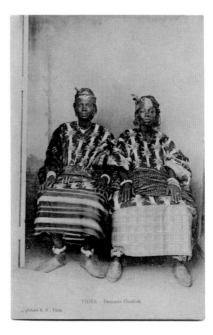

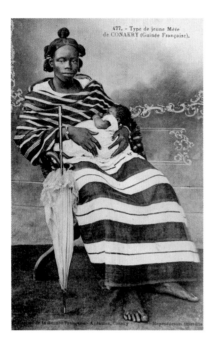

477. - Type de jeune Mère de CONAKRY (Guinée Française).

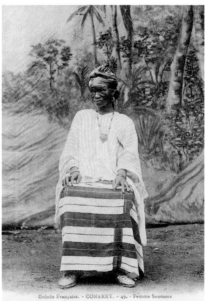

Guinée Française. - CONAKRY. - 52. - Femme Soussous

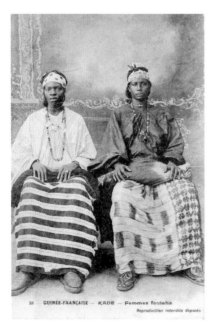

21 GUINÉE-FRANÇAISE. - KADE - Femmes foulahs

Guinée Française. - CONAKRY. - 49. - Femme Soussous

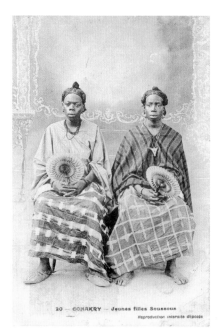

20 — CONAKRY — Jeunes filles Soussous
Reproduction interdite déposée

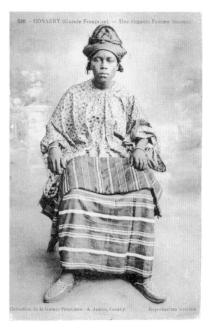

520. - CONAKRY (Guinée Française). — Une élegante Femme Soussou
Collection de la Guinée Française - A. James, Conakry Reproduction interdite

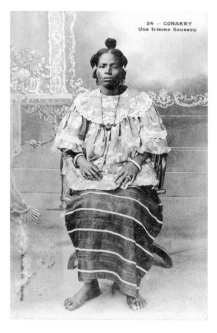

24 — CONAKRY
Une femme Soussou

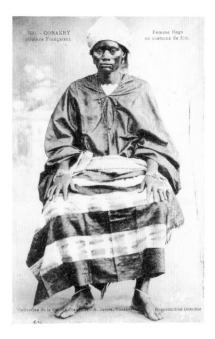

500. - CONAKRY
(Guinée Française). Femme Bага
en costume de fête.
Collection de la Guinée Française - A. James, Conakry Reproduction interdite

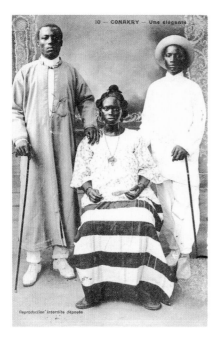

10 — CONAKRY — Une élégante

Reproduction interdite déposée

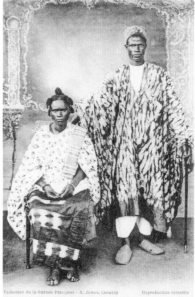

Collection de la Guinée Française - A. James, Conakry Reproduction interdite
483. - Type de Traitant Soussou de CONAKRY (Guinée française) et sa Femme.

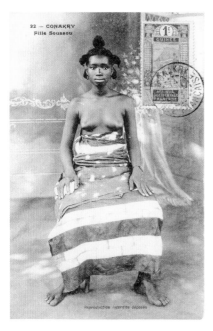

22 — CONAKRY
Fille Soussou

Reproduction interdite déposée

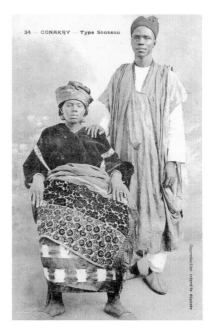

34 — CONAKRY — Type Soussou

Reproduction interdite déposée

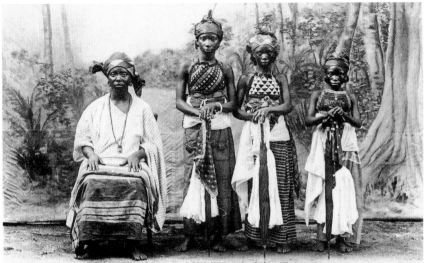

Desgranges et Decayeux Guinée Française. - CONAKRY. - 46. - Groupe d'Excisées

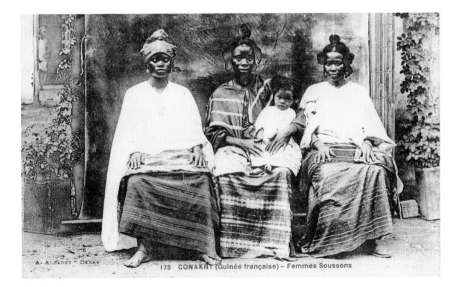

A. Albaret - Dakar 178 CONAKRY (Guinée française) - Femmes Soussons

THESE IMAGES, taken between 1870 and 1890, are among those that date to the first five to twenty-five years of African photography. Many of these early photos displayed a divide between Les Élégantes, bedecked in costly clothing and jewels and staged against Orientalist opulence, and the multitude of anonymous men and women who represent often bedraggled typologies of motherhood, trades, or "tribe." Juxtaposed with the glamour of the wealthy sitters, most wear simple white loomed cloth. Most of it guinea cloth, woven in India, shipped to Europe, and re-exported to Africa, it was an important commodity for colonial traders. Both the sitter and the cloth tell an important story. Cotton-growing and weaving in the upper Niger region (Mali) were documented in Arabic texts as early as 1068. Colonial trade models, with their system of extraction, industrialization, and resale of ancient techniques and material resources, were able to turn significant profits, and turn people and traditions into pawns.

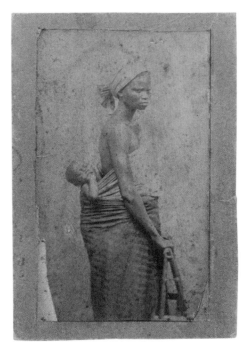

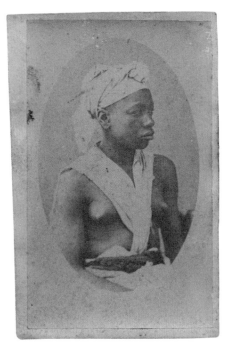

Untitled, c. 1870
Unknown · Unknown

Untitled, 1880
Unknown · Unknown

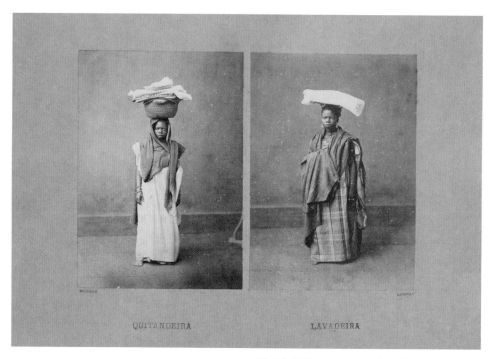

QUITANDEIRA LAVADEIRA

Untitled (Greengrocer and Washerwoman), 1883
Unknown · Angola

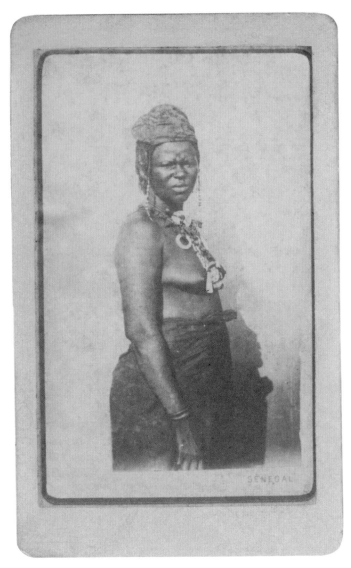

Untitled, 1880
J. Barbier · Senegal

LES ÉLÉGANTES ORDINAIRE carry children, pound millet, appear in situ at home, representing a mix of the colonial sublime and the erotics of service.

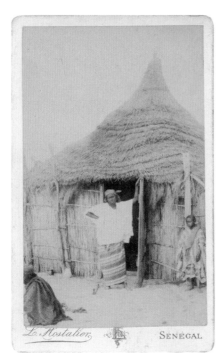

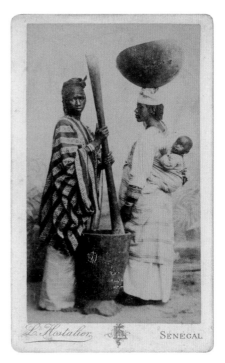

Untitled, 1890
L. Hostelier, Photographie des
Colonies, Paris · Senegal

Untitled, 1890
L. Hostelier, Photographie des
Colonies, Paris · Senegal

WE TRACE THE LEATHER STRING, crisscrossed on a noblewoman's chest, of an amulet: a tiny leather sleeve in which protective Koranic verses are sewn. Bohemian Czech beads and printed fabric pouches, amulets too, circle her waist.

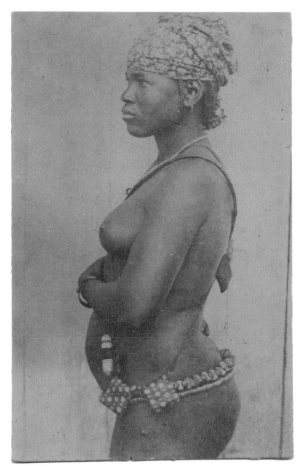

Untitled, undated
Unknown · Senegal?

BETWEEN HER BREASTS, on a string of glass beads, rests a single Venetian chevron, paid for with its weight in gold, or a number of slaves. The chevron was born in factories in Venice in 1482, just as Elmina Castle, the oldest European building south of the Sahara, birthed the transatlantic slave trade on an outcropping on the Guinea Coast in what is now Ghana.

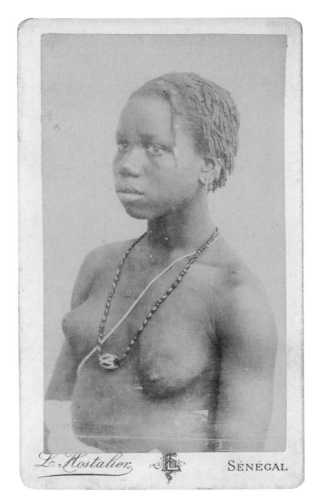

Untitled, 1890
L. Hostelier, Photographie des
Colonies, Paris · Senegal

THE ORIENTALIST LENS was pointed on both the servants and the elites. The Wife of the Decipherer wears gold coins at her neck. A woman in a curious cap and elegant beads of unknown origin, a European dress covered at the breasts by a *pagne*, a wrapper or cover cloth worn in the style of married women. It is assumed to be a photo from a Colonial Expo, a fairgrounds where colonial subjects from every corner of the Empire were shipped to re-create the domestic life and "curiosities" of their culture; or possibly a circus or a theater; or the French Jardin d'Acclimatation or a copycat—Napoleon III's famous Paris zoo, which evolved from a garden of plants and animals from the colonies to a place where untold men and women had been trafficked or coerced with promises of work to board boats for exhibition as curiosities. Two other women, who we might assume to be servants in Morocco or the Arabized northern Sahel, pose in modest finery, the near absence of jewels marking their social class.

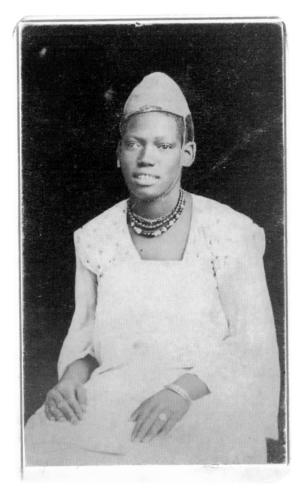

Untitled, c. 1870
Unknown · Unknown

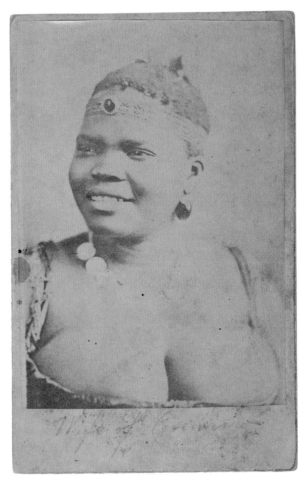

Wife of . . . (a dechiffrer), 1870–80
Unknown · Unknown

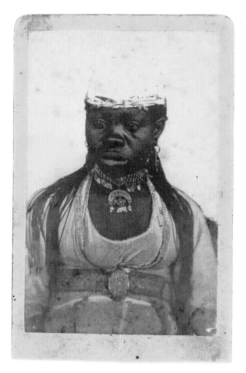

Untitled, c. 1870
Unknown · Unknown

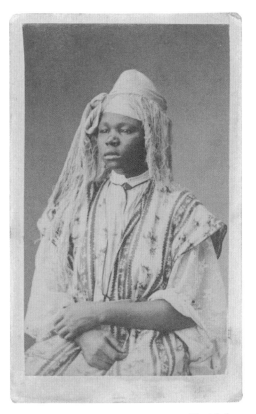

Untitled
Victor Du— · Unknown

A LITTLE GIRL in a fine handwoven indigo *iro*, or wrapper, attendant to and possibly the daughter of the "Black African," Reverend James Greaves, is captured by John Parkes Decker, himself a "Black African." Historians claim Decker is both Gambian and Sierra Leonian. We do know Decker worked in both nations, and in Senegal, Ghana, and Nigeria, among possible others. For some time before this, he worked for the Colonial Offices in London, mostly photographing buildings and street scenes and later returning mainly to studio portraits.

The photo was taken in the Calabar area of Nigeria. The girl's cloth, among other markers, reveals that she is someone of the inner court—possibly a chief's court? Possibly the inner sanctum of the church with its hidden syncretism? Greaves cuts a figure in his wild silk *agbada*, a Yoruba prestige robe. He is a reverend in the most un-missionary-like attire.

The turn of the century was a time when Nigerian Christians were voicing widespread opposition to deepening segregation in the church, the increasing placement of whites in church leadership, and to colonial officials' pulling back from earlier support of African church movements, where once measures of autonomy from a central European body were at times encouraged. A call for a return to native dress by elites became a means to voice opposition to colonialism. For women, the *iro* was the most symbolic of tradition and their powerful role in the church. A two-yard length of cloth— it is the foundation of every woman's dressing, synonymous with intimacy, motherhood, "women's work," and the mysteries and spirituality particular to the feminine. A child is wrapped at birth in *iro*, it is tied to its mother's back in *iro*; *iro* is a cover at night, a woman's undergarment, a sarong at home, a skirt, a cover cloth for fancy attire, it is used to tie the head (a *gele* in Yoruba culture), and at death, it will accompany the corpse. *Iro* was the possession that was "truly African" and uncontaminated by colonialism, if you ignored that its length was also the chief measure for currency in the colonial trade.

The wearing of indigenous dress represented a deep rejection of colonialist moral claims. Wearing *gele*, as the girl does, and *iro* was in stark contrast to the parasols, costume laces, plaids, and other array of European fabric and the gloves and hats featured by Nigerians at church. Church attire had become so important to Christian identity—the wearers written up in the weekly social registers and described in detail in Lagos newspapers. The

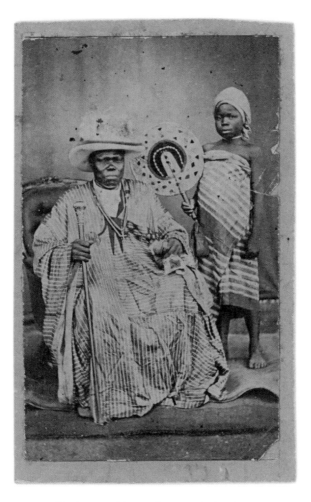

The Reverend James Greaves, Black African, c. 1890
John Parkes Decker · Nigeria

emphasis on clothing was also a display of closeness to the colonial order: what you wore—what kind and grade of European fabric—told others about your morality vis-à-vis proximity to church and state power. When this revolt began with the elite in this very milieu, it upended the social order of the churches and larger institutions.

Decker's photo is a remarkable record of this era.

THERE ARE LEGIONS of photos of the *circoncis*—girls and boys who have concluded puberty rites with circumcision and a grand communal celebration. The colonial erotic and pornographic repertoire is so vast, there is a category of postcards of *fetish girls*, as they were blanket-named, who were photographed in predictable gatherings, naked except for strings of waist beads that secured a tiny loincloth. The photos circulated as curio but also very pointedly as soft pornography, printed on postcards that traveled across continents. Often the girls pictured were almost intentionally a part of the "joke"; they were unremarkable or odd in some way, but they still managed to have remarkable breasts: long or pointed or large, or perhaps shamingly "perfect" in a way that would appeal to a European man battling the heavy spell of Empire.

In the photos of the celebrated Lisk-Carew brothers, Alphonso Sylvester and Arthur, the sitters are known to be new initiates of the ethnically diverse Sande, or Bundu, societies in neighboring Liberia, Sierra Leone, Guinea, and Côte d'Ivoire where, at puberty, girls are sequestered in the forest for a year or longer and taught the complex rituals and laws of secret societies. What they learn there about sexuality and marriage, medicine, economic power, and cosmology is the basis for the larger civil social order in which women have uncommon power, which the Sande will help them to negotiate for a lifetime.

Born and raised in Sierra Leone, Alphonso and Arthur were Krios (Creoles)—descendants of repatriated slaves, mostly from England and its Atlantic colonies, who settled in what was a British-established abolitionist colony beginning in the late 1700s. These abolitionist sentiments inflect the legacy of the very prosperous and important studio they opened in Freetown in 1904. They worked almost exclusively in postcards, which for a long time

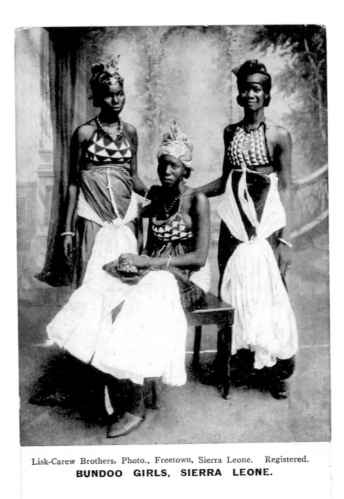

Lisk-Carew Brothers, Photo., Freetown, Sierra Leone. Registered.
BUNDOO GIRLS, SIERRA LEONE.

Bundoo Girls, c. 1920
Lisk-Carew Brothers, Freetown · Sierra Leone

was not only a novel format but also one intended for commerce and for circulation—abroad. The photos of the girls might have been commissioned by their families in celebration and would also be shared in marriage bids. Perhaps the girls were invited to sit for the brothers. They present themselves, fresh from the initiation, wearing the hairstyles of their mothers, as is tradition, or headscarves—the privilege of adult women. They were inevitably bare-breasted in the forest, but in the studio they don halters, worn by every *circoncis*, with appliqué designs that are meant to communicate their status and the identity of their family and clan and the Sande to which they belong. They bodies have been marked—by the trials of the forest seclusion, by circumcision, and by ritual scarring. For the camera, they possess a dignity, a palpable ease behind the studied formality of their pose.

The Lisk-Carew brothers participated in a global trade of these images, and more benign but equally beautiful and enchanting ones of termite hills and market scenes and masquerade. Their anti-colonial leanings are inflected in the camera's eye, which captured subjects on their own terms.

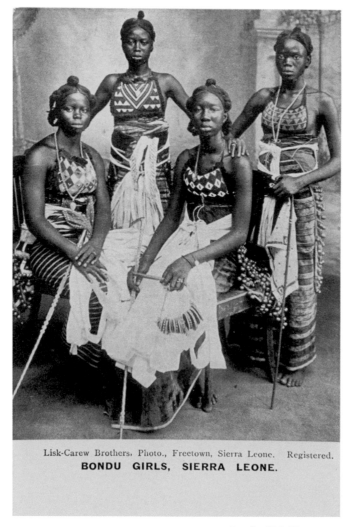

Lisk-Carew Brothers, Photo., Freetown, Sierra Leone. Registered.

BONDU GIRLS, SIERRA LEONE.

Bondu Girls II, c. 1920
Lisk-Carew Brothers, Freetown · Sierra Leone

A. DESCHACHT, one of the earliest European photographers, of whom little is known, took incredibly intimate portraits of women in Guinea that capture faces and skin with an intentional eye, which was often a failing of European photographers, who rendered their subjects over-lit or in shadows. The details of dress—the very folds of cloth and the stitching and ties and gatherings—are unusual. This is a portrait of the *circoncis*, from a time after their return from Sande initiation, when they danced for the community. In similar photos, symmetries and belonging are always the foreground, but Deschacht goes around this and renders something beyond the expectations of the colonial photograph: the subjectivity and feeling in the young women's faces, here a strength and forthrightness shaded by mournfulness.

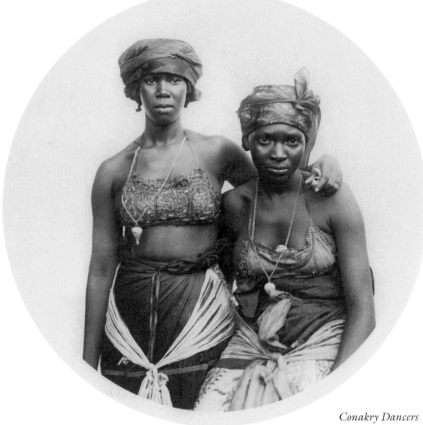

Conakry Dancers
A. Deschacht · Guinea

AT HOME IN SAINT-LOUIS, SENEGAL, the girls sit proudly beneath a tapestry with Islamic motifs, a prestige item often brought home from hajj. They've gathered a statue—more a souvenir than fetish or plaything, it seems—whose origin is not clear, and a foreign broadside, both intentionally displayed on their laps. They wear dresses that suggest they are Christian. This is the house of civil servants, perhaps. Educated people who likely move in several milieus and have families that cross class and religious and ethnic lines. The girls have a look of expectation: an awareness that the world is large and made up of many things that they have the gumption for.

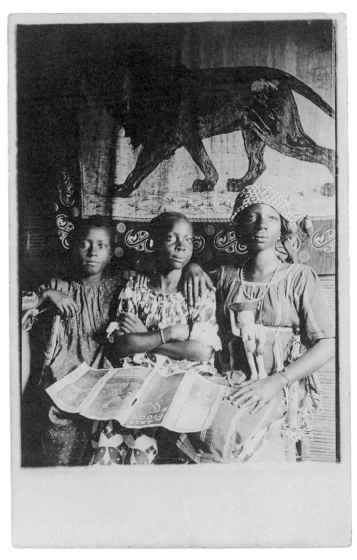

Untitled, undated
Unknown · Senegal

THE FULANI CHIEF'S WIFE wears a crown of brass behind the arc of her hair. She displays power in several worlds at once: traditional power, chieftaincy power, and wealth, the power of colonial access, exemplified by an eyelet lace blouse, a costly import. Not much worn.

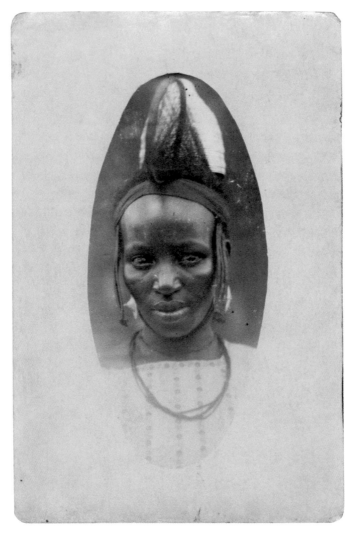

Wife of the Chief II, 1927
Unknown · Guinea

THE P. TACHER STUDIO was the reserve of the European colonial elite and wealthy Senegalese, including members of the city's Creole and mixed-race families whom he captured over generations. Mostly Catholic, in a country of majority Sufi Muslims and traditionalists, they expressed their identity by an adherence to the fashions of the church and of France—modesty of dress, its lack of color, only delicate imported jewelry—whether or not the church or France would ever be theirs.

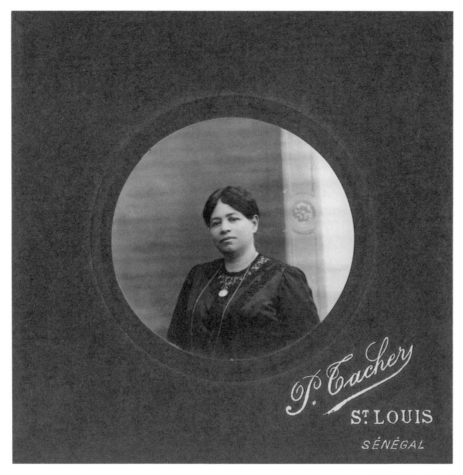

Untitled, undated
P. Tacher, Saint-Louis · Senegal

Henrietta Cole of the Conakry Creole elite was no doubt of the nationalist, Christian moral fold, descendants of former captives in the Americas, the Caribbean, and Brazil who repatriated to nations along the West African coast with abolitionist and sometimes more radical leanings. She's a schoolgirl, her hair cut short until she's available for marriage. Her hair, the pearl earrings, a simple blouse—these are ornaments of power, establishing a certain birthright among mostly Muslim and animist girls.

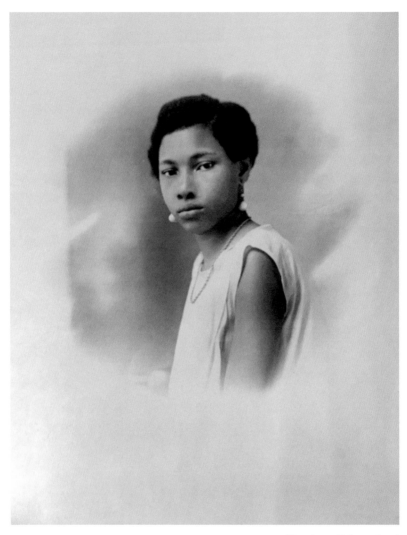

Henrietta Cole, undated
Unknown · Guinea

THE COLE WOMEN and extended family gather in front of the house of Mme. Therese Cole a few days after the wake keeping, where she was laid out at home on her bed. Who was she to Henrietta? Their modest French Catholic clothing and pith helmets are Creole tribal wear.

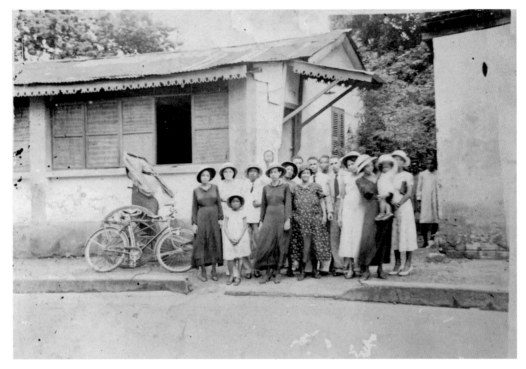

The Cole Family at Home, c. 1936
Unknown · Guinea

SERVANTS WERE OFTEN INCLUDED in photos in order to display wealth and status. The wife of the Sultan—the sovereign leader of Congo's Muslim states, with ties to the Zanzibar caliphate—wears presumably silk stockings and the French linen dress of a Christian woman, and stacks of the kind of ivory that mark her as a woman who owns many other human lives.

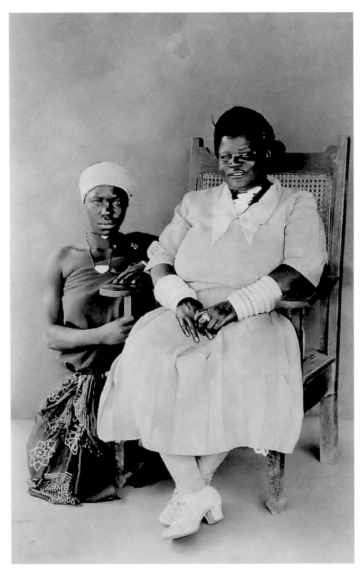

The Wife of the Sultan of Mwenda and Her Servant, c. 1900
Gabriel L. · Panda, Katanga, Congo

BEHIND THE MODEST CORNER of a colonial house stands a woman in a white poplin dress and a choker fashioned of coins. She holds a staff, a power object. A sign of conferred status. Who "owns the papers" to this house? In many cultures, a woman's *petit pagne*—a loincloth worn below one's wrapper or dress—is called "the papers to the house"; she holds her position or power at home through the passions of her man. Perhaps this woman is the true owner. Not the wife of a "Big Man." Not a concubine. When she hangs her washing on the drying line, it is not a title, a display of her powers. It's just laundry.

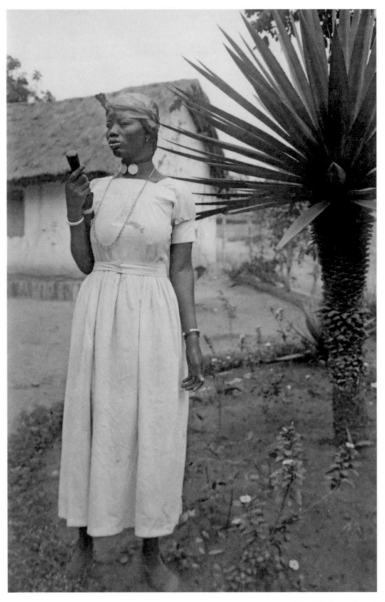

Untitled, undated
Unknown · Congo

Whose room is this? Who chose the flower for my lady's hair?

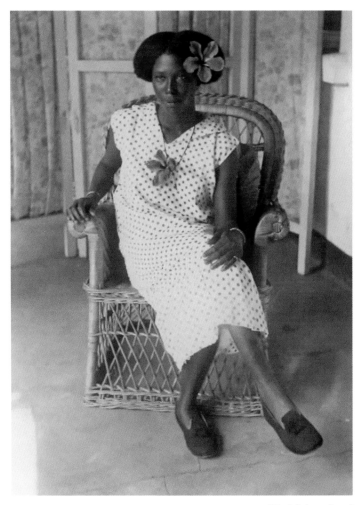

Untitled, undated
Unknown · Belgian Congo (Democratic
Republic of Congo)

THE HISTORY PRESERVED IN FASHION can be more resilient and revealing than what is stored or memorialized in other kinds of repositories. Colonialism's destruction of so much of African societies since the late 1400s means that most African-Atlantic monuments are considerably young. Fashion, in which both the past and rapid change are alive, offers a record that buildings, agencies, roads, borders, and currency cannot support as they shift, erode, devalue, and are imperfectly resurrected over periods of dramatic change. The architecture of clothing, the overwhelmingly sculptural quality of dress in much of the African-Atlantic on the social landscape vis-à-vis the body can stand in for many of these other losses. Fanti women, growing up in the shadows of the slave forts, wear something at once so up-to-the-minute and so old, implicating them in centuries of the economy of colonialism.

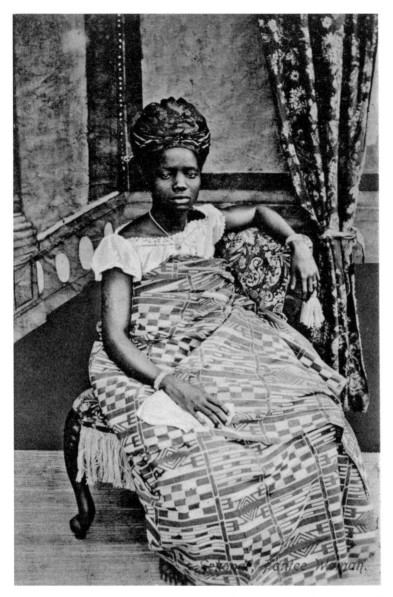

Fantee woman, Sekondi, undated
Unknown · Gold Coast (Ghana)

No More Velvet is the name of a mid-twentieth-century Yoruba indigo cloth design. Yoruba *adire,* a cloth featuring patterns created by hand-painting with a starch paste, or by tying or stitching and folding fabric, as a resist in a dye bath, could be made with the finest detail and enough saturated indigo dye so that it had as much texture and luster and elegance as European velvet that disappeared from the markets as colonial regimes and later the Independence and post-Independence governments struggled with politics at the level of the highly lucrative cloth trade. Velvet was the costly purview of the African Madame. Indigo of that dark hue surpassed the cost of velvet. Photos of European velvets in Africa are rare, and when seen, put the ingenuity and creativity of indigenous cloth-makers into place.

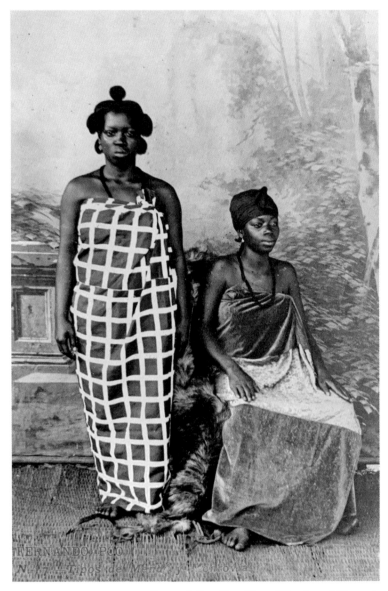

Fernando Poo, No. 7-Type of Mende and Monrovia
Collection Alfonso XIII/Editada por Geronimo
Lopez, Sta. Isabel · Equitorial Guinea

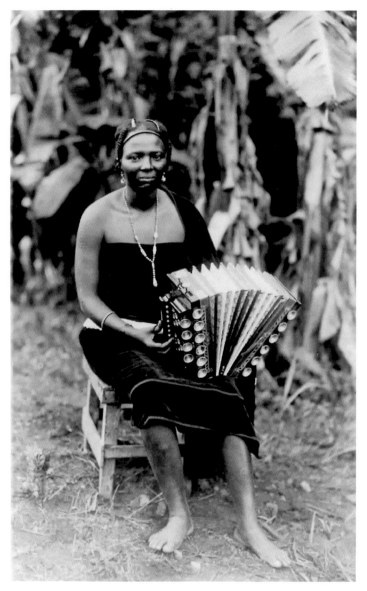

Accordion, 1930
Unknown · Kapushi, Congo

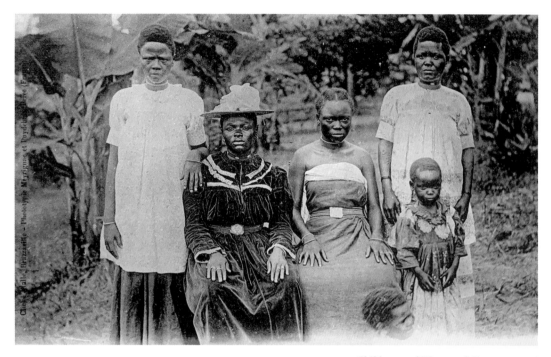

Children and Women of Congo, c. 1906
Unknown · Congo

As she dressed to take photos, did she choose her wrapper deliberately? My Husband Is Worthy. That's the name given to the design by the big shop owners, the Mama Benz, of Ghana, and later Togo, who are the historical conduits for the Dutch cloth trade with West Africa.

The Mama Benz relish their status as Madames. They are good Christian and Muslim women and good wives. And they are fiercely independent from male patronage and wealthy enough to have bought the Mercedes they drive. The complex network of market women who they commandeer and who in turn inform them of tastes and opinions from the street, help them to arrive at decisions about whether a design sent from Vlisco, the self-named Chanel of African cloths, in Helmond, the Netherlands, is acceptable enough to inspire them to name it or attach to it a proverbial meaning. "You are not wise like the Spider Anansi!" "Sorry, I'm taken." "Nothing in my hand I bring." "Nkrumah's pencil." "Money flies like a bird." "My body is here but my spirit has flown abroad." Cloth that is beloved, that is named, is considered fine enough to be a dowry item, to be worn at weddings and funerals and baby-naming ceremonies, to become a "heritage" item in a woman's cloth box and therefore a costly commodity for the ages, historically stored and respected like money, never devaluing over a woman's lifetime.

That day, was she feeling love for the man? Or was it just that the color suited her skin? A woman less independent might wear it in a campaign to flatter him. Or if the husband was cheating, and it was common gossip, she'd be making a show of nonchalance. African women dress for their own spirit, their god or ancestors, for custom, for each other, to speak socially. Men are trapped in the crosshairs.

Wax is about women's power and life's vicissitudes.

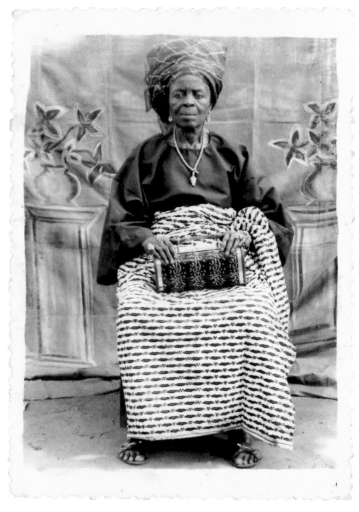

Untitled, undated
Unknown · Benin

A Portuguese trader named Nogueira traveled to the Vlisco headquarters in Helmond in the Netherlands to order a custom-made wax cloth. His idea was a design with six spark plugs, or "bougies," to celebrate that its wearer had a six-cylinder car, like the Benz, one of the ultimate signs of wealth. During World War II, Vlisco was forced to close production, but the designers played with Nogueira's design. This trial was the first shipment after the war to the completely dried-up Congolese market and became one of the most iconic wax designs continent-wide. The Congolese assigned a different meaning: the wearer is a woman strong enough to take on six men.

LEFT
"Mama Benz," Vlisco.
A modern tribute to
Mama Benz, released
as part of a Mother's
Day campaign in the
mid-2000s.

RIGHT
"6 Bougies," Vlisco,
1940

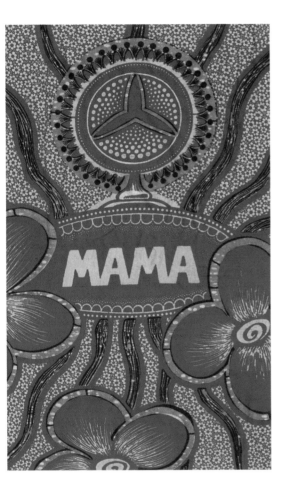

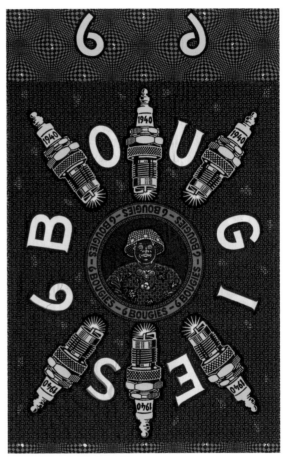

To SHOW LOVE, support, or sympathy, or your belonging to others—your mother, your spouse, co-wife or wives, your clan, or women's savings club, your market association, your dead in-law's family—when you go out, you buy a cloth that has been chosen with great care by those people to represent the occasion, and you sew it in your style, and then you go out. You make an anchor. In pictures, it looks powerful: a couple or siblings or a funeral gathering of hundreds all wearing one pattern. And then there is a powerful idea in Ghana, which exists in other places too, that a woman can "tie your cloth to their cloth." They can figuratively tie their wrapper—that foundation of African womanhood—to another's and join spirits to bury the dead or celebrate or protest or mourn together to put grief behind them. One's spirit is said to have domain in one's cloth because cloth is essential to the work of birthing and naming, serving God and the ancestors, and living and dying. Cloth, as an anchor, is a mighty tool.

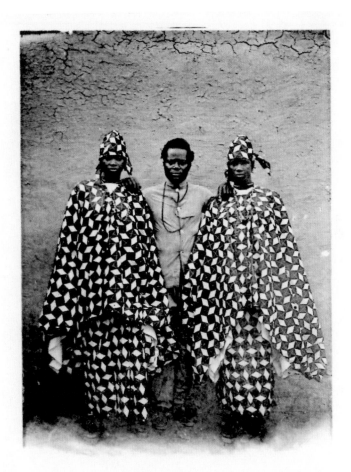

Colonies Françaises.

SÉNÉGAL-SOUDAN. — Nos élégantes de Djenné.

H. Danel, à Kayes

Our Elegants of Djenné, undated
H. Danel, Kayes · Mali

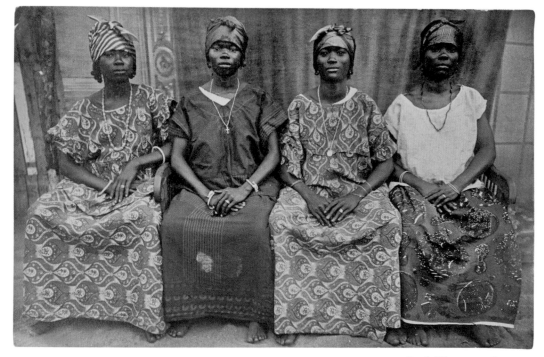

Baule Women, 1928
Unknown · Côte d'Ivoire

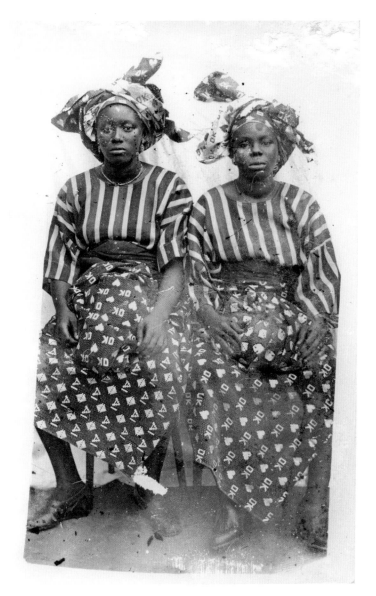

Untitled, undated
Unknown · Nigeria

TARKWA, GHANA, IS A SMALL CITY long known for gold and manganese wealth. Jacob Vitta, assumed to be Ghanaian, set up a studio there around 1900 and recorded in his photographs life around one of the world's biggest gold mines. Women at the age of marriage, their new wardrobes of wax cloths on display, signal their newfound maturity and good taste. Their cloth will have been slowly collected by their mothers. The photos will be shared among family and potential suitors. To afford photos from a studio like Vitta's separates them from others.

There is a pressure to achieve perfection in dress, down to the slap of one's slippers and the sound of jewelry, including the suggestive swish of the beads tied at their hips. The woman displayed in the studio is a demonstration of their ability to navigate the complex social customs that won them their status. Beauty, reserve, perfect grooming: all are equated with a morality, an essential goodness.

At the end of a woman's life, her cloth box, in which she stores dowry items, along with jewelry and dresses and unsewn cloth that she has kept as bank savings, will be opened in front of the family. The volume of cloth collected throughout a woman's life is a show of celebration—a marking of her respect and wealth.

Each cloth, and every photograph kept, will reveal a piece of her story.

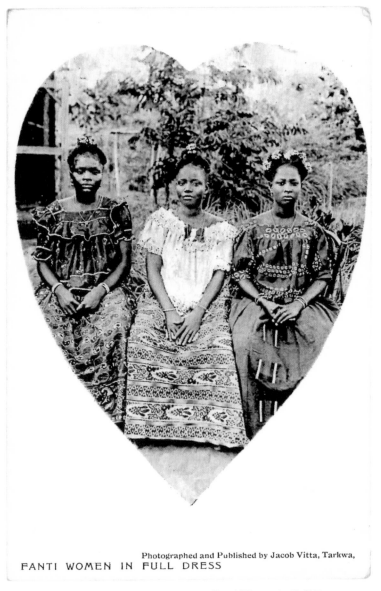

Photographed and Published by Jacob Vitta, Tarkwa,

FANTI WOMEN IN FULL DRESS

Fanti Women in Full Dress, c. 1910
Jacob Vitta, Tarkwa · Gold Coast (Ghana)

WHEN PIETER FENTENER VAN VLISSINGEN, the head of Vlisco, then P. F. van Vlissingen & Co., decided in the 1850s to knock off ancient batik *tulis* designs in their Helmond factory and resell them on the Indonesian market, Indonesians summarily tossed them out. They were too static and had none of the beauty of the hand-painted originals. The cloths, transported to and from Indonesia on ships that stopped at bulking points at the slave forts in Ghana, were introduced to the West African trade, where cloth accounted for more than half of the commodities exchanged for African resources. Ghanaians liked them. Some say that it was the return of Dutch-conscripted Ghanaian soldiers from Indonesia (1831–1872) who fostered the taste for the cloth. They settled near the forts in Cape Coast in an area that would come to be known as Java Hill, and enjoyed a newfound status annexed to the Dutch colonial officers. The batiks they wore were seen as a prestige cloth. Java cloths became trademarked by Vlisco, who sold them later as a specialty cloth. Slowly they became Africanized, the patterns and colors hybrid with traditional woven and Dutch wax cloth designs. Java cloth became essential to every woman's cloth box.

Untitled, undated
Collection of Aladji Adama Sylla · Senegal

Untitled, undated
Unknown · Senegal

BUNNIES, COLONIAL SHIPS, lunar landings, football, women talking on telephones, the latest hairstyles, advertisements for soaps and home appliances all made their way to fabrics called fancy prints, or fancies. Vlisco introduced fancy prints to West Africa hoping to capitalize on the novelty of using local and European images instead of solely patterning, as well as the ability to use multiple, brighter colors than was possible with wax, which was limited by intensive and costly production. World Wars I and II had crippled trade between Africa and the West. Transport was severely limited, supplies were scarce, and textile companies were feeling keenly the loss of what amounted to the equivalent of millions of dollars of profits from the African market. In those years Vlisco returned to research, and the fancy market, for which production could partly be carried out in Africa, carried the company. They could be made trendsetting and up-to-the-minute in their messages. Women who bought them enjoyed their air of sophistication, of being a souvenir—a "letter" from the village or abroad when featuring a scene from Paris or a coca farm or the tower of Big Ben. But they were also not considered respectable enough for life's big occasions or for the cloth box—they were of lower quality, not attesting to a life well lived the way that woven prestige cloths and wax would. Eventually, fancies would bear photographic images or drawings from photos. Individuals could order in amounts to "make an anchor," spreading among family members and communities, a shared engagement or wedding cloth, a burial cloth. Politicians and traditional leaders could order cloths bearing their image and distribute them among their followers—a perfect vehicle for a cult of personality. And women found a new vehicle of protest. They began to use the cloths as a means to comment politically: a leader's face or a factory image worn upside down, a face perhaps spread across one's buttocks on a disheveled cloth, was a piercing critique for women whose dressing was often guided by ideas of fastidiousness and the honorific.

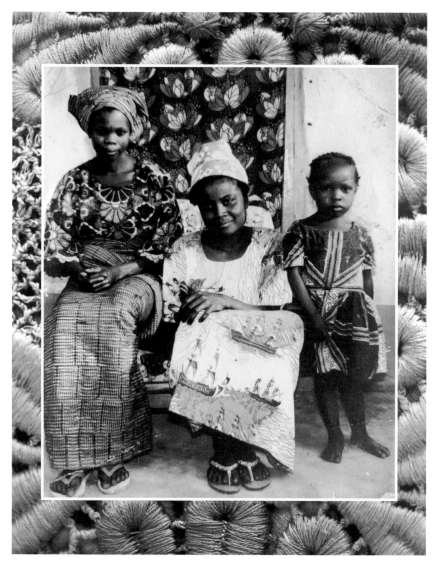

Untitled, 1979
Easy Motion Photo Service, T/Wada, Kaduna · Nigeria

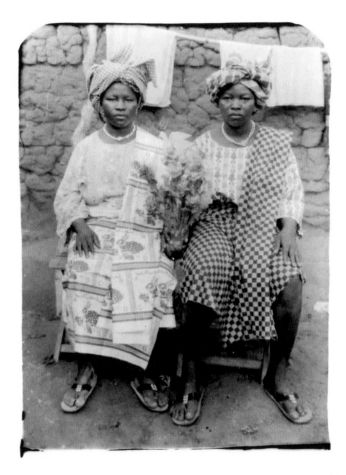

Dahomey Women, c. 1920s
Unknown · Benin

Untitled, undated
Engagement fabric · Mali

Untitled, c. 1950s
ICODI Factory · Côte d'Ivoire

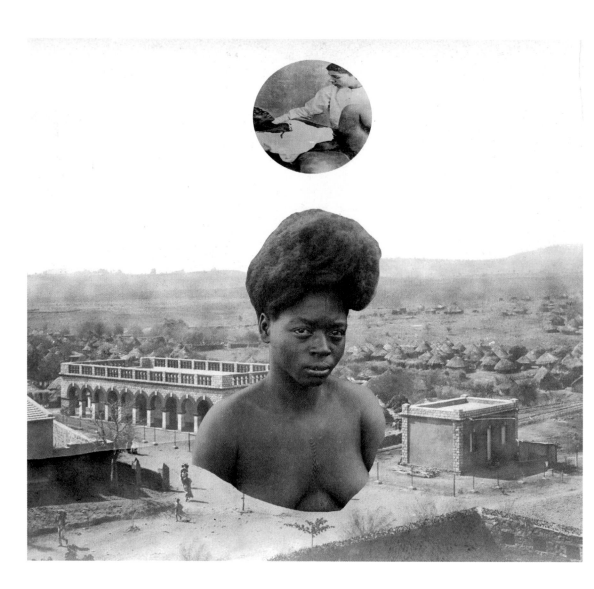

CHAPTER III

DRESSING AND UNDRESSING, 1900-1940

UDES REVEAL the most about the politics of the studio, and about African fashions and systems of trade. Not always so much what is bared but what is left on, or put on, is where we are able to find meaning. Nudes expose relationships between colonial photographers and the African female sitters where, at best, a grave power imbalance is evident, but more often intimations or raw truths of sexual liaisons or coercion are revealed.

There is a kind of secondary (to the original capturing of bodies by colonial paramours, aggressors, or entrepreneurs) trauma in the recirculation of these photos to infinite anonymous viewers. Some were made for private consumption, but most were reproduced in postcard format and circulated without borders. Colonial postcards are still widely available, often recaptioned or filled with mocking or lewd racist scrawl by the people through whose hands they passed.

Photos of African women's heads and backsides—the famous *femme de dos*—which fetishized nudity, hair, and scarification, were not only erotic by nature, but also put in service of typologies and pseudoscience, intended as catalogs, distancing acts, and fascinators. These images were common in the colonial repertoire. By the 1950s, African photographers like Malick Sidibé (Mali), Youssouf Sogodogo (Mali), and J. D. 'Okhai Ojeikere (Nigeria), who were trained in colonial studios or by the State, would revisit these sittings, but in a way that radically altered the relations of power between the sitter and the artist. Theirs were consenting acts of reverence or preservation, or documentation with an artist's eye, driven by political concerns and by way of feeling into their subject's lives. No doubt African male photographers traded in the erotic, but there is no historical record of images near to the colonial one.

IN THE BEGINNING THERE WAS SKIN. And skin was as cloth: decorated, coded. Tattouage. Cicatrice. Henna or indigo. Earth and minerals and dyes rubbed in.

Through the colonial lens, adorned and marked bodies are made into fetish objects. Agents of magic. Witchcraft. Darkly sexual. Abhorrent. Not of God. Not guided by the rationality of Enlightenment or bourgeois Victorian values.

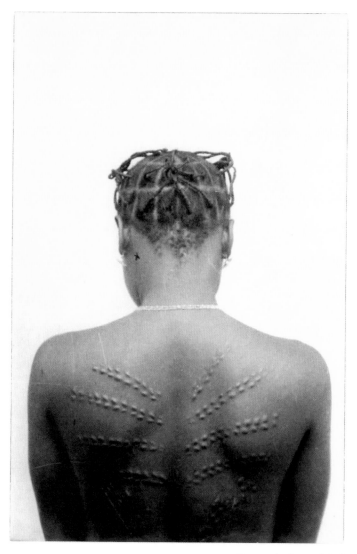

Femme de dos, undated
Unknown

CLOTH WAS FOR BEAUTY, less for cover than for embellishment. With Islamic and Christian campaigns and incursions, baring the thighs or buttocks became taboo, a social offense. African textiles had value when they mimicked the patterning and meanings of cicatrization and other body arts. Colonial traders and African competitors developed damasks and guipure laces, woven and dyed and using other materials from these aesthetics, even as body modifications became more rare. In this photo, European cloth, clearly with an Asian root, meets the body.

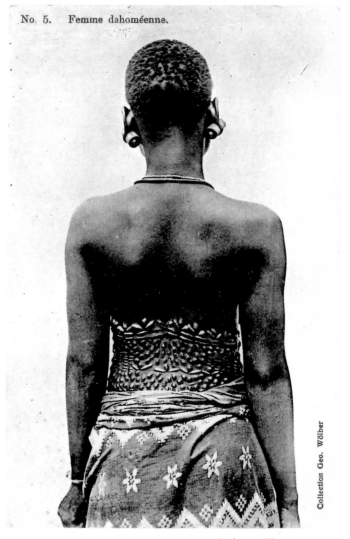

No. 5. Femme dahoméenne.

Collection Geo. Wölber

Dahomey Woman, c. 1900
Collection Geo. Wölber · Benin

THE FANTI PEOPLE of the central region of the Gold Coast were one of the first to have contact with European colonial traders, beginning with the Portuguese in 1471. Resplendent in missionary-styled dress with Edwardian and Victorian influences, and traditional Fanti hairstyling and jewelry, especially beads and silver pieces from the Fanti Royal court, this woman represents the class of elite traders—men and women—and the concubines and wives of colonial officers, who orbited them.

Baubles and inexplicable adornment like this were understood to be part of the witchcraft, the foolery, of African women. But more often it was the greed and shame of the colonizers, conflated into sexual desires, that are fixed in the camera's eye. Women who held power in both the African and colonial worlds were seen as treacherous and beguiling, negotiating two Gods.

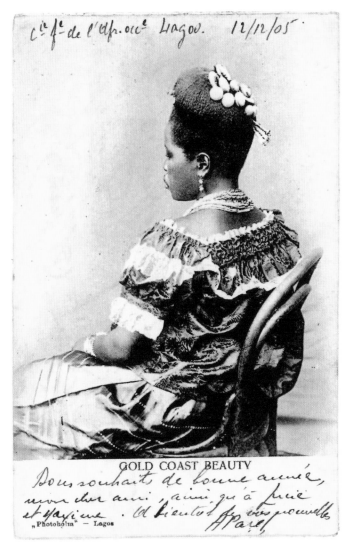

Gold Coast Beauty, c. 1905
Photoholm-Lagos · Gold Coast (Ghana)

COLONIAL UNDERTHINGS. A Madame's underthings. A gift for a wife or concubine or mistress, carried from abroad or mail-ordered through colonial agents. The leopard's skin. To stand on it is to be charged with a power reserved for royalty, a harness of the power of the animal and its spirit realm. Here in a colonial home, a wild trophy.

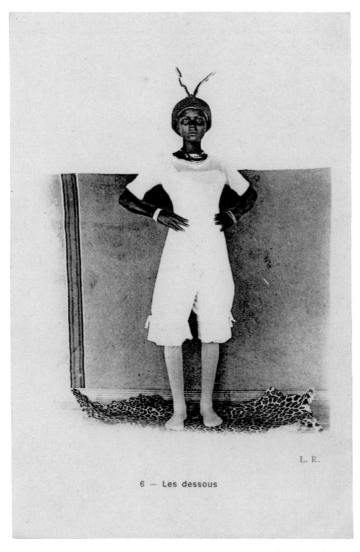

6 — Les dessous

The Underthings, Unknown
L. R. · Congo

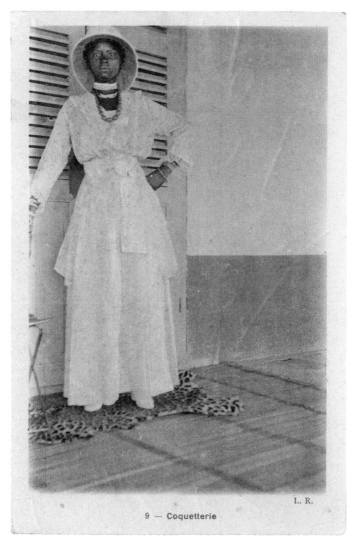

9 — Coquetterie

Coquetry, c. 1924
L. R. · Central African Republic

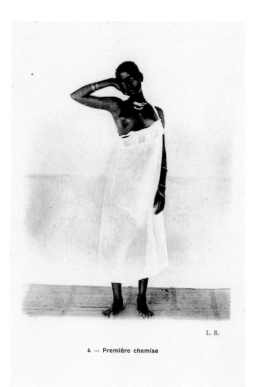

4 — Première chemise

First shift, 1920
L. R. · Central African Republic

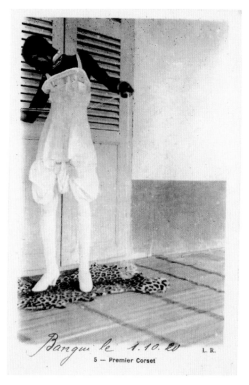

5 — Premier Corset

First Corset, 1920
L. R. · Central African Republic

THROUGH THE COLONIAL PEEPHOLE.

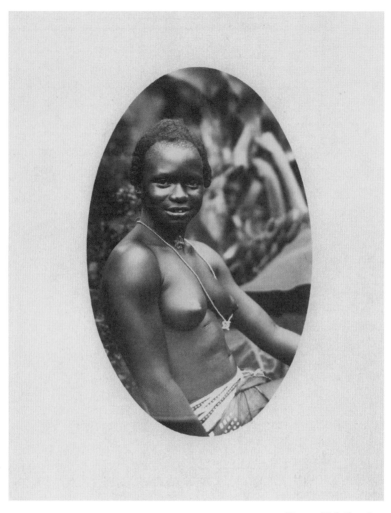

Young Girl, Conakry
A. Deschacht · Guinea

IN PRIVATE HOMES and pastorals. The photo becomes its own trophy. White French mules. Private Amazons. A bush girl in the chair sent to Porto-Novo on a ship.

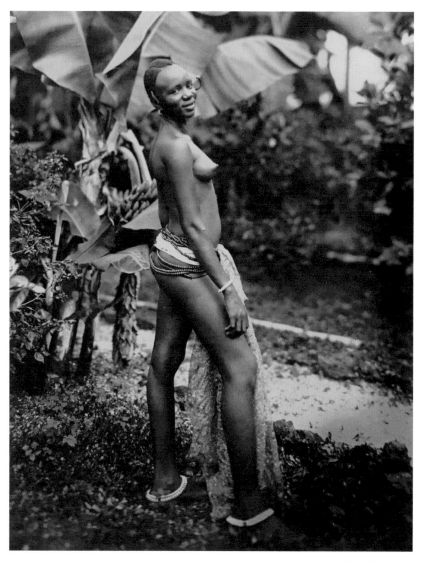

Untitled, 1920
Unknown · Guinea

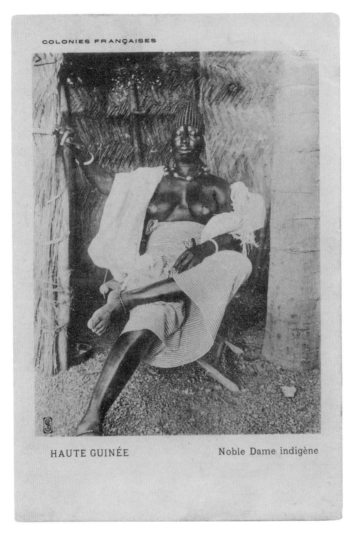

COLONIES FRANÇAISES

HAUTE GUINÉE Noble Dame indigène

Noble Native Lady, Haute Guinée, Colonies Françcaises, 1906
Unknown · Guinea

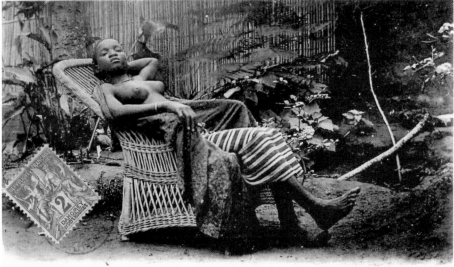

Colonies Françaises. - **DAHOMEY**. - Jeune femme du Niger

Cliché J. N.

Young Woman from Niger, c. 1920
Unknown · Dahomey, Benin

Untitled, undated
Unknown · Unknown

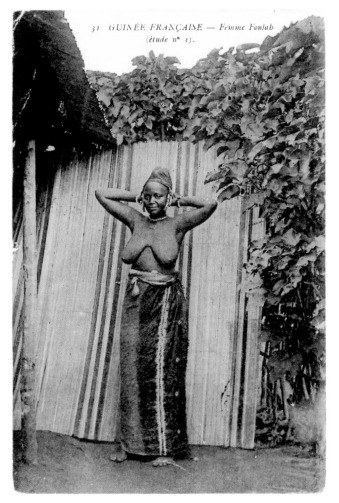

Fulani Woman (étude no. 2), c. 1914
Edit. G. Calvayrac—mon Guiraud et Mader · Guinea

THERE IS A SAYING among women: "If you cover your head, your soul will be closer to the sky."

Untitled, c. 1926–30
Unknown · Benin

MOTHERS TIE BEADS around the calves of newborns for spiritual reasons and to shape them. By puberty, beads accent the beauty of the calves, a place of eros. Through the camera's lens, they are turned into a fetish joke. Naked in beaten brogues at the table. Countless colonial diaries remark on the false value Africans put on things, how easily seduced they are by cheap cloth, cheap beads, cheap objects, which they will wear any way but as intended. Why, you could trade ounces of gold for nearly anything. But what was all of this fuss over gold? the women might ask, if you could stand in a field as you farm and literally kick it from the ground.

Untitled, c. 1926–30
Unknown · Benin

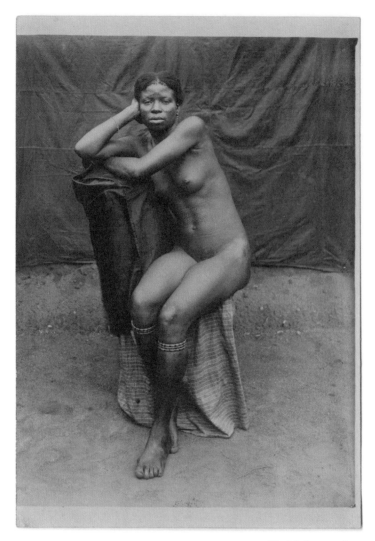

Untitled, c. 1926–30
Unknown · Benin

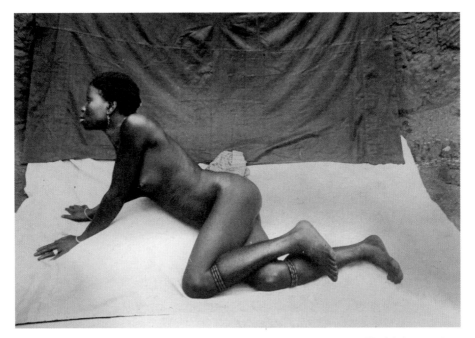

Untitled, c. 1926–30
Unknown · Benin

A CANNIBAL WOMAN waits on a colonial stage. Fang women, they are insatiable. You know them immediately by the raised scars like crocodile skins running between their breasts.

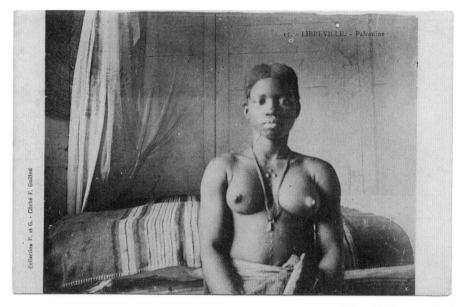

Libreville Fang, undated
Collection P. et G.—Cliche F. Guillod · Gabon

THE MOTHER OF ART DECO, down to the stacked bangles. The perfect Paris party guests.

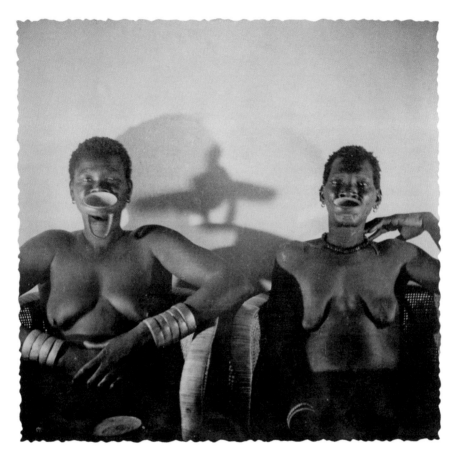

African Negresses, 1937
Véritable photo originale du journal illustre, Le soir,
Albert Bouckaert · Chad

THESE IMAGES OF KROBO GIRLS from the Gold Coast and a Dan girl from neighboring Côte d'Ivoire during the time of puberty rights are of the large category of colonial fetish-girl images that circulated between Africa and Europe and other colonies, decidedly as an ugly joke and as soft porn. The other, from an unnamed African studio, was likely commissioned by the young woman's family. Colonial fears and anxieties about sexuality—and the mysteries they ascribe to African girls and to circumcision, which was not practiced at all uniformly in the African-Atlantic—hovers alongside the titillation of bare pubescent breasts. The girls are dressed painstakingly with family heirlooms and dowry items including beads, which the Krobo are famous for making and trading along the coast and to European merchants. In the colonial gaze, all the finery falls away.

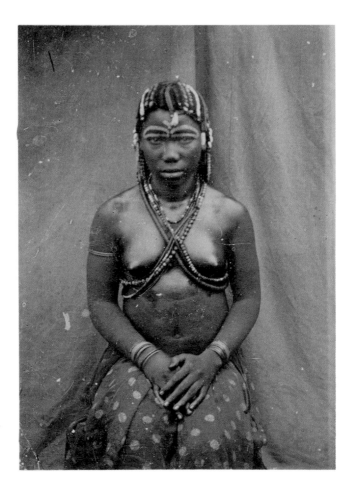

Dan Woman, undated
Unknown · Côte d'Ivoire or Liberia

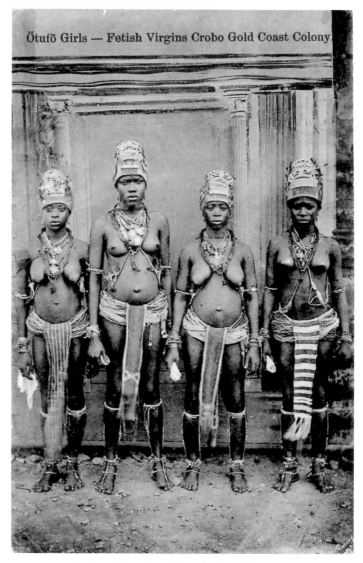

Otufo Girls, Fetish Virgins, Crobo Gold Coast Colony, c. 1910
Unknown · Gold Coast (Ghana)

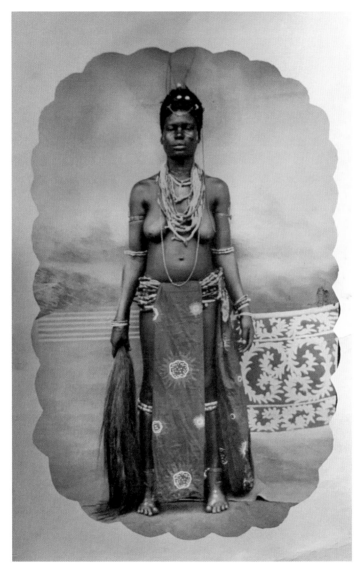

Untitled, undated
Unknown · Unknown

"Captive" girls wear *pagnes*. Along the African-Atlantic coast in the 1700s and 1800s, a human life could be traded at the same value—the very cloth itself used as currency.

But these girls are held in an indigenous system of bondage, after the end of the transatlantic trade, and long after the decades of illegal trade that followed.

Their *pagnes*, the camera's fetishizing lens, suggest they are royal concubines or initiates to a shrine—pawns in conflict over territories or unpaid debts.

Two Captives (French Sudan), c. 1903
A. B. & Co. Phot. Nancy · Senegal

THE *FEMME DE DOS*. Odalisque. Femme Orientale. Ladies who wait. Bewitchingly.

Type of Soudan Francais, c. 1929
Lauroy, ed. · Mali

Untitled, undated
Unknown · Congo

BONNEVIDE SÉNÉGAMBIE

Bonnevide Senegambie, undated
Unknown · Senegambia

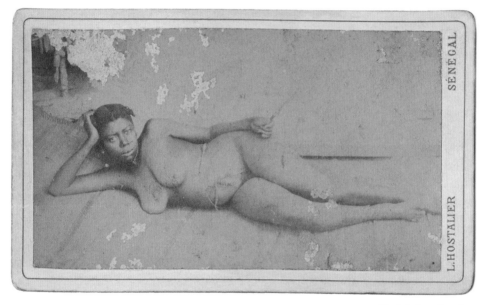

Untitled, undated
L. Hostelier · Senegal

Young Negress, Casablanca, c. 1909
Edition J. Gonzalez & Co. Cie · Morocco

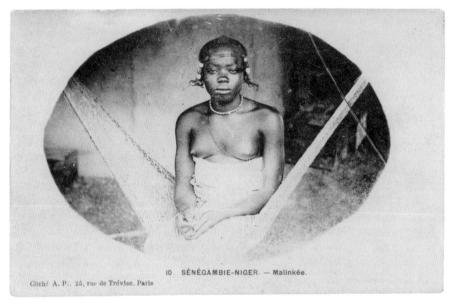

10. SÉNÉGAMBIE-NIGER. — Malinkée.

Cliché A. P., 25, rue de Trévise, Paris

Malinkée, Senegambia-Niger
Cliche A. P., Paris · Senegal/Niger

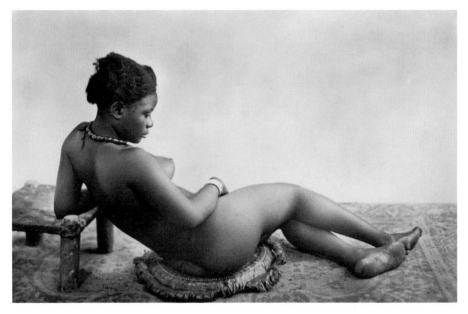

Untitled, c. 1920
Unknown · Unknown

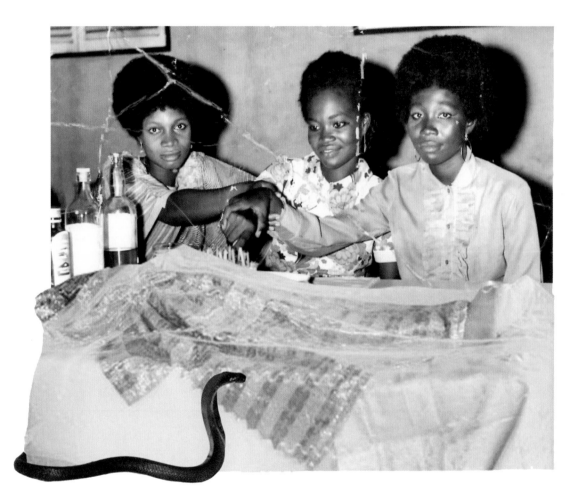

CHAPTER IV

CLOTHES FOR A NEW NATION

INDEPENDENCE AND POST-INDEPENDENCE,

1957–1970s

N 1957, Queen Elizabeth's relinquishing of British power to Ghana's Osagyefo Kwame Nkrumah was marked by dramatic celebrations on the world stage. By 1960, dubbed The Year of Africa, seventeen nations—mostly West African, including Mali, Benin, Niger, Nigeria, Senegal, and Togo, which are featured here—followed suit, swiftly altering the political landscape. By the time of Independence, fashion systems in Africa were changing as radically as political systems, and textiles, given their significance as an economic bloc—representing one quarter to just under half of foreign imports for most African-Atlantic nations—were caught up in any discussion of a way forward. (As part of Ghana's Independence campaign, Nkrumah doubled the import tax on printed textiles and removed the tariffs on others in order to spur local fabric production and gain a leg up on companies like Vlisco.)

At the level of everyday lives, dress and the camera were as powerful decolonizing agents as anything in the 1950s–1970s. African women, appearing in various "uniforms" of statehood as they marched and paraded and performed Independence strivings, were redrawing the economy of power and identity in the social and political imagination. Younger women and girls adopted heady expressions of a counterculture. The new fashions were the dramatic proof of a conscious engagement with pan-African and other radical politics across the continent and the globe, even when they appeared more aligned with spaghetti westerns and Jimi Hendrix. Independence had opened a crossroads for identity, a loosening of strictures for many women, and an explosive optimism.

Behind the scenes, other newly independent nations were also acknowledging the huge revenues in textile production and sales. In the 1960s

women in West Africa spent 12 to 19 percent of their annual income on cloth. Food and cloth were their largest expenditures. Respectability and status were dependent on the display of a New African Woman in dress—part of the Independence and postcolonial project.

AUNTY KORAMAA

ONE MEMORABLE HEROINE, Aunty Koramaa, reappears in several frames during Independence and post-Independence. An Akuapim woman from the hills beyond Accra, she grew up partly in Jamestown, one of Accra's oldest settlements, flanked by the Guinea Sea and a buttress of old colonial fortresses. She is pictured here in 1956, on the eve of the Gold Coast's Independence, through the 1966 coup that deposed Nkrumah and introduced military rule; and then into the mid-1970s, as Ghana and other nations entered what are known as The Lost Years of serial coups and continual military tumult. In the first photograph, her hemline is nearing the miniskirt, which will become the rage just years later in England and revolutionize fashion worldwide. But still, the respectability of Independence-era modesty in service of nation-building prevails. Her image reflects a radically changing self-identity and the evolution of a nation's consciousness as it entered an age of liberation politics—even if for many it was just at the surface of fashion—decidedly influenced by American Black Power.

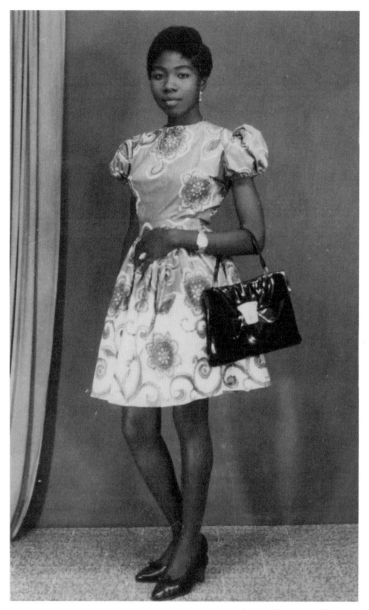

Aunty Koramaa III, 1956
Dan. Minolta, Accra · Ghana

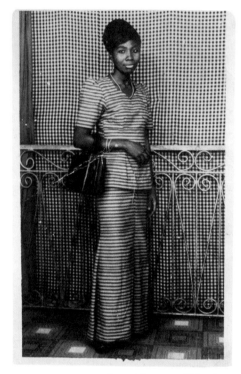

Aunty Koramaa IV, 1960s
Unknown · Ghana

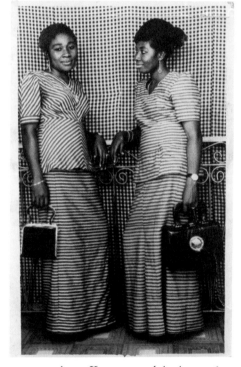

Aunty Koramaa and Aggie, c. 1960s
Unknown · Accra, Ghana

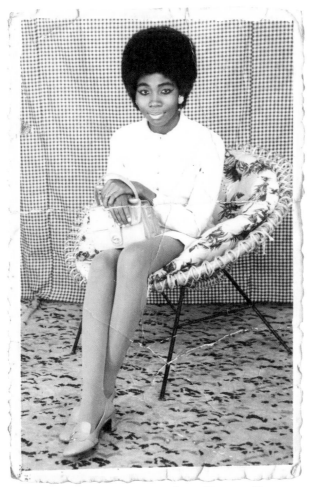

Aunty Koramaa II, c. 1975
Diamond Photo Studio No. 4, Accra · Ghana

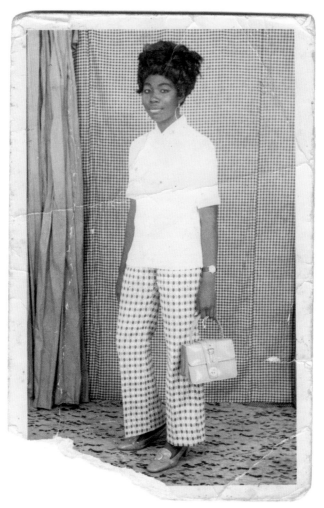

Aunty Koramaa, c. 1975
Diamond Photo Studio No. 4, Accra · Ghana

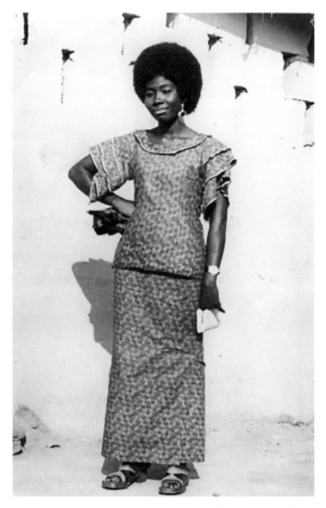

Aunty Koramaa I, c. 1970s
Unknown · Ghana

POST-INDEPENDENCE AUNTIES

THE *BOUBOU*, an essential, foundational dress, is encoded with the history of Islamic jihad in Sahelian Africa, the Christian missionary, and African anticolonial revolution. Both religious movements, along with the sewing machine to zip up the sides, have kept it—a once-unsewn blousy cover that both reveals and conceals—in line with laws of modesty. This sitter wears a sheer *boubou* of Austrian lace, with suggestive peeks at the brassiere. Traditionally the *boubou* could be opaque or sheer or made of eyeleted or open-weave textiles, and part of its sensual appeal and mystery was the way the wide neckline and the open sides from armpit to mid-waist revealed glimpses of the *pagne* and beads or breast. Along with the bell-bottom pants and platform sandals, her *boubou* tells a story of pleasure, seduction, and a happy containment of both tradition and 1950s-to-'70s-era modernity as African women followed their penchant for religious faith, tradition, social freedom, and up-to-the-minute fashion. Her shoes and pants are Latin- and U.S.-influenced via communist alliances with newly decolonized nations. Black Power, U.S. civil rights, and an expanding worldview of pan-Africanist thought began to signal a new kind of social independence, a new sexuality, and a cosmopolitanism that was distinctly homegrown, reaching out to the world.

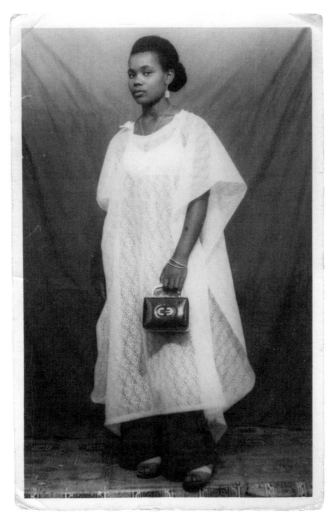

Aunty DeiDei, 1970s
Unknown · Ghana

IN SENEGAL, as in most places, the requisite quality Western handbag and matching shoes and wristwatch were the uniform for good dressing. Your bag was its own occasion, fit to occupy as much space in the studio as a sister or friend. Safieddine, the son of Lebanese migrants, ran a popular Dakar studio through the 1970s and left one of the best records of modern Senegalese fashions.

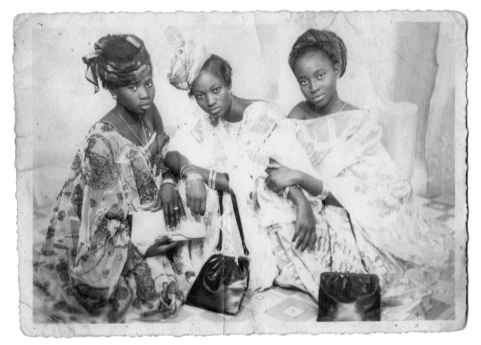

Untitled, c. 1960
Youssef Safieddine/Studio Safieddine · Senegal

BY THE EARLY 1970S, fashion forecasts from the runway and photos in local newspapers featured women wearing hot pants, body-hugging shorts in florals and neons; tops with low necklines; mid-calf or below-the-knee boots; and broad "Polaroid" sunglasses. AFRO-DELIC. PSYCHODELIC.SEXYDELIC. THE 'DELICS took over headlines and cafes and party rooms.

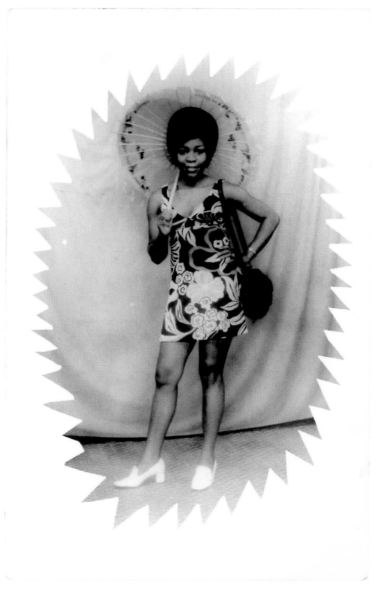

Woman with Umbrella, undated
Unknown · Togo (?)

IN POST-INDEPENDENCE GHANA, in the space of ten years, the notion of what sartorially made a woman in cities and towns a "Proper Woman" changed radically. The requisite handbag, matching Western shoes and wristwatch were still considered essential. The Victorian formality and Portuguese old-world lines of the *kaba and slit* had emerged as Ghana's national dress around the time of Independence. A tight-fashioned corset-like bodice with elaborate décolletage or sleeves and a long, tight, fitted skirt often with a high slit exposing the leg—its adoption unified the hundreds of indigenous ethnic groups and disparate regions of the small nation. By the late 1960s it loosened into more indigenous styles of draping. The rise of the Afro, and especially the Afro wig, meant that *duku*—a silken or brocade headscarf, most often tied like Queen Elizabeth's but more often at the nape than at the chin—and other headscarves and head coverings were often abandoned. Headgear was essential for married and mature women, so to discard it was to explode the boundaries of respectability, only to replace it with a radical American globe of hair.

Later women would joke that the wig was not a wasted expense; not fully combed out, it gave "power" to the shape and height of their *duku* when they returned to it again.

Short skirts have persisted—even into the 2000s—in the Ghanaian social imagination as the uniform of prostitutes, long after they arrived en masse in the secondhand shipments of the Kennedy era.

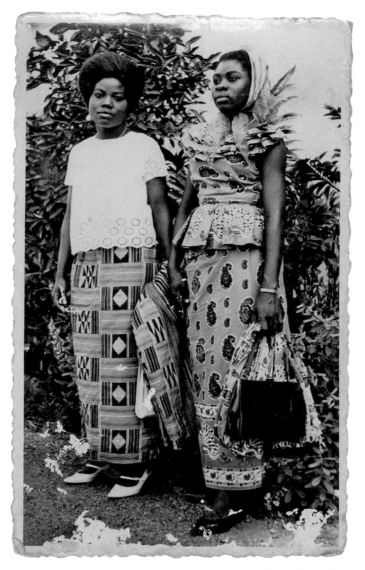

Untitled, c. 1960s
Unknown · Ghana

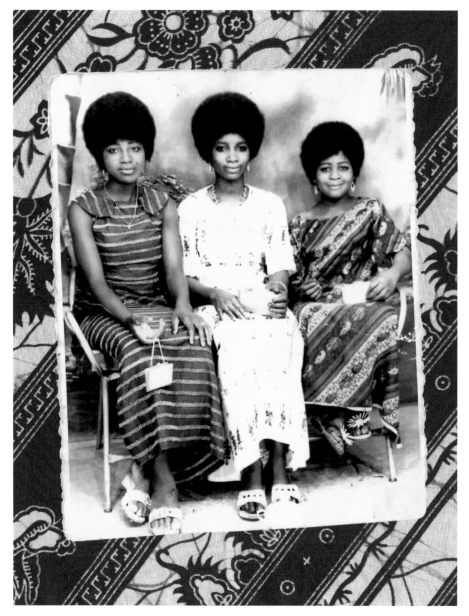

Friends Who Know What to Do, c. 1972
Unknown · Accra, Ghana

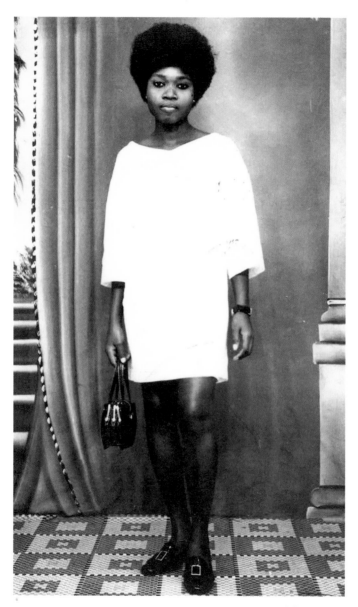

Untitled, Unknown
Studio de Paradise/Day & Night Photo Studio,
Teshie, Accra · Ghana

THE INDEPENDENCE ERA had a sweeping excitement, a feeling, that seems reflected in every posture.

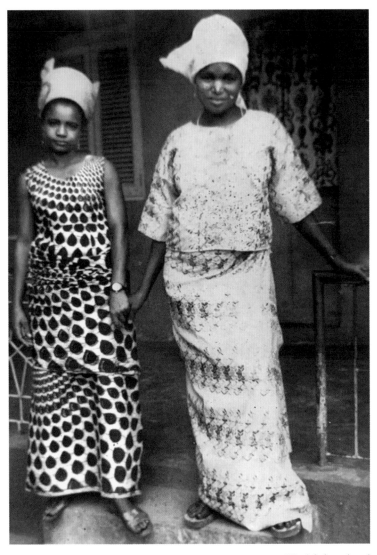

Untitled, undated
Unknown · Nigeria

WITH THE AFRO came the return to updated traditional styles, like this Fulani one, also adopted in the Diaspora as an expression of Black Pride.

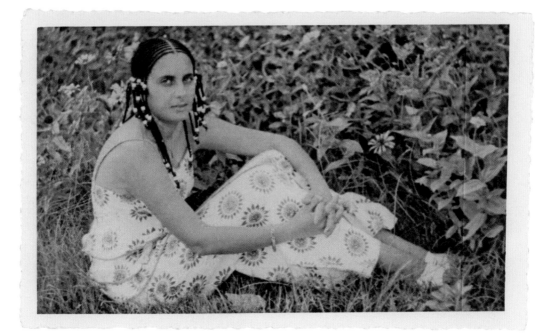

Marie Rose, undated
Al Hadji Bassirou Sanni,
Mopti · Mali

On the eve of Independence, foreign aid to Africa included support of infrastructure, like the 1955–56 building of Adomi, or Senchi, Bridge, the first modern arch-suspension steel bridge in West Africa, constructed so that the immensely profitable cocoa harvest could be more easily moved across the Volta River to connect with roads to coastal ports. Precolonial modes of hairstyling that had been considered pagan or unsophisticated during the later colonial era returned. Changes to the landscape, new architecture, inspired new geometry in these hairstyles. They drew on "tribal" identities and old traditions but symbolized modernism and national pride. Sections of hair were wound with heavy, black, Chinese mechanical thread used in ceiling fans so that they extended like cables and radiated like spokes of the sun, or were sculpted into styles that riffed on meanings, similar to the naming of wax cloth designs. "Senchi Bridge" was a threaded mod hairstyle. It was also a name given to a cloth; the wavy pattern a comment on weathering life's changes, like the violent sway of the bridge, and encouragement for its other interpretation, "Change Your Life." Women in neighboring countries, competing fashion centers, would answer to a name or coveted style with their own, rendering their individual history, a favorite song, a new excitement, and optimism, and then someone somewhere else would answer back.

LEFT
Untitled, undated
Unknown · Unknown
"Point" hairstyle

RIGHT
*The very latest coiffure of a
Gold Coast belle*, undated
E. O. Hoppé · Ghana
A variation on the
"Pineapple." Both of these
hairstyles are popular across
the African-Atlantic.

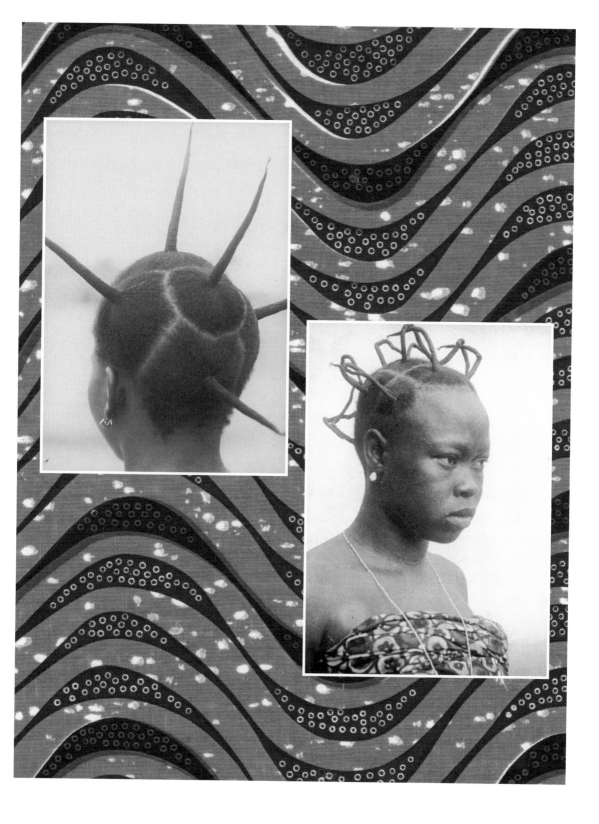

A YOUNG WOMAN in an Accra studio truly emblemizes post-Independence cosmopolitanism. You can read this photo a dozen ways, because the mix of props and adornments is eclectic in the way only a studio in an African metropolis can be. Is it post-puberty rites, or festival costume? Or simply the wearing of something from the past but never captured in this way? Her tattooed hand tells us she is Krobo. Her shorn head tells us she's school-aged. *Dzigida*—waist beads—are universals. She wears the silver chains of the Ga people. Fur on her legs that suggest the Muslim north. The beauty of big city studios is that they have their own rules and space for mixed metaphors as fantasy-making. And always, white city sandals.

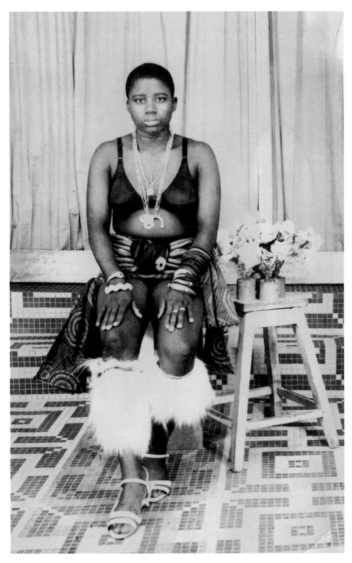

Untitled, undated
Unknown · Ghana

In the late 1950s, as the winds of decolonization blew hard, U.S. senator John F. Kennedy introduced international legislation that opened the door for increased U.S. humanitarian aid to Africa, delivered chiefly in the form of secondhand clothing and food staples such as bulgur wheat, cooking oil, corn flour, and baby formula. The foods had little or no nutritional value. There arrived a new wave of goods: T-shirts, jeans, brassieres, and other undergarments. A bathing suit fashion culture emerged on and off the beach, along with public health concerns over skin and other infections.

Sierra Leonians would call the clothing "John Kennedys"; Ghanaians would call them *obruni wawu*—"the white man has died."

The arrival of these secondhand clothes brought a crisis for local seamstresses and tailors who lost work. Young Independent governments, and those reconstituting after coups in the 1960s that would overthrow these nascent leaders, were trying hard to balance neocolonial attempts to reconfigure their power with an awareness that cloth and clothing and especially local production were a powerful economic bloc on which they had a slippery hold.

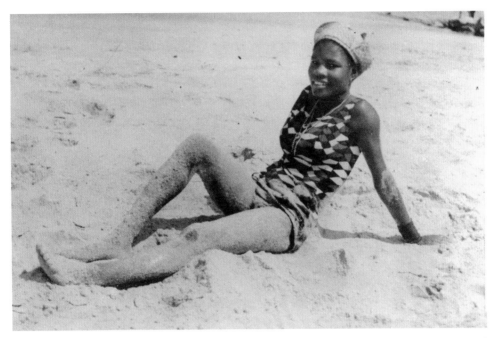

Untitled, undated
Unknown · Unknown

It is unclear when hand-painted backdrops that featured aspirational objects like mansions and airplanes and state-of-the-art kitchens began to appear in Ghanaian studios—most likely in the late 1970s. With a new post-Independence wave of immigration to the West and to Communist Eastern Europe, largely for schooling and professional training, the idea of international travel—which was the coveted right of only a very few—took over the popular imagination. These young women wear a mix of clothing. Wrappers or *pagnes* represent traditional fashion. The T-shirt, a sought-after item—a new one, nearly as rarefied as travel, instead of one picked from the *obruni wawu* market—is a show of modern chic, as is the women's hat, a church bonnet with some of the attitude and architecture of a headscarf. The rubber flip-flops, or *chaley-wateys* ("Charlie, let's go!" from the British legacy), were not yet considered gauche bathroom slippers. Royal Scepter is the name given by the market women to anoint this Vlisco design as worthy of a woman's cloth box. By that era, the popularizing of power symbols on clothing, once a reserve of royals, becomes an expression of national identity—of Ghanaianess—and a symbol of aspiration and access, just like the airplane.

Untitled, 1977
Uncle Alade Photo, Kaduna · Nigeria

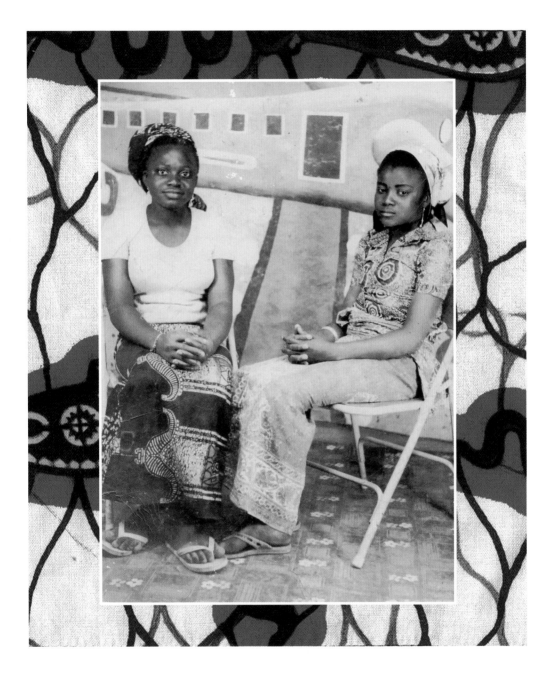

SIDIBÉ'S ICONIC PHOTOGRAPH is one of his most widely celebrated. It is an emblem of the era. Three years after Independence, Bamakois finely tailored siblings dance in a way that feels like a herald. Lithe and playful. They touch heads in the way of lovers, but their intimacy is like that of two yolks pressing together against a membrane ordered to break. Intimately bound and yet soon free.

Indigeneity and the African-modern will struggle, sometimes violently, to be contained through the coming decades. And fashion and the lens will continue to indelibly record what will be lost to other projects of memory.

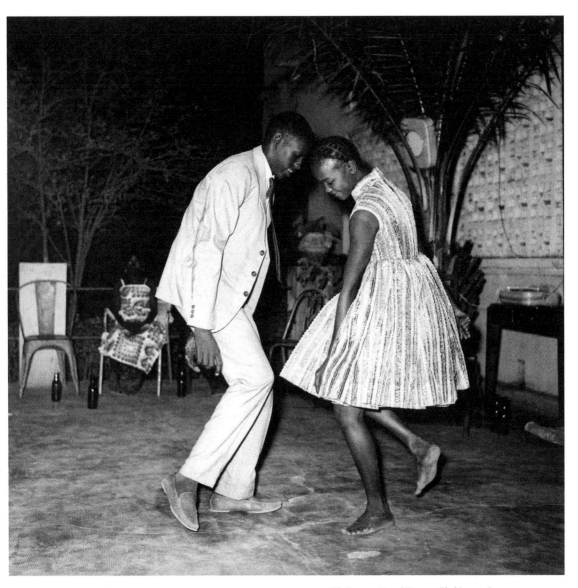

Christmas Eve (Happy Club), 1963/2013
Malick Sidibé · Mali

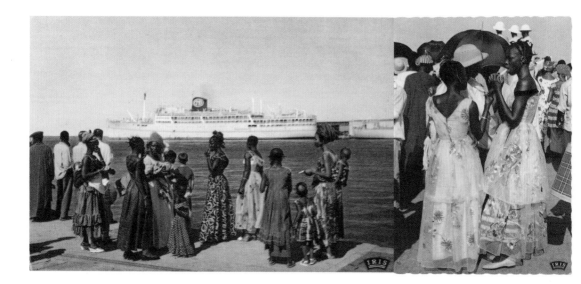

POSTNOTE

COLOR PHOTOGRAPHY became popular in the West in the early 1960s, but was not widely adopted by fine art photographers for nearly a decade because of the instability of the early colors, and was even more slowly adopted in Africa, due to the enormous cost of importing materials. By the time color "snaps" began to be more widely enjoyed, the cadre of the African Masters were nearing retirement, and business at many African studios was slowing down as well, propelled by the popularity of new point-and-shoot cameras and photo-processing machinery introduced in Asian-owned photoshops. Then there are stories of Masters such as James Barnor of Ever Young Studio in Accra, Ghana. He was the first to contract with AGFA and offer color processing, but he would soon leave for the UK, where he would work in fashion and keep up a robust career in several genres for many more decades.

In 1991 when I made my first travels to Ghana, Côte d'Ivoire, and Senegal, I took my camera rolls to the local film shop and spent six times what I would have at home for muddy-colored shots churned out of machines that often shut down. When I moved to Ghana in the early 2000s to live for some years, it was still cheaper to send the rolls home with someone who was traveling back to New York and have one set stored at home and the other mailed back to me. Every time I journeyed home someone would invariably hand me months of savings and ask me to bring back a camera. The fancy point-and-shoots they ordered would corrode within six months from the humidity and dust. Most people would have done better paying a few *cedis* to the itinerant photographer who showed up at the bars and church yards and did the weekend rounds of funerals and naming ceremonies. The Masters who were slowing down by the 1970s: it was then unknown that they would be fêted on the world stage in the 2000s, by then a small gather-

ing of old men well into their eighties and nineties. Heroes of the future.

Color film signaled the end of one Golden Era in African photography. But it was also the slow making of our present one, where selfies and social media have birthed an unprecedented Africa photo culture, and also exciting new photographies with many African women artists. The color revolution meant that more women had access to the camera. By the early 2000s there emerged a critical number of professional female photographers, freed of many of the confines of working in traditional modes, leading as image-makers. Heroes of the new future.

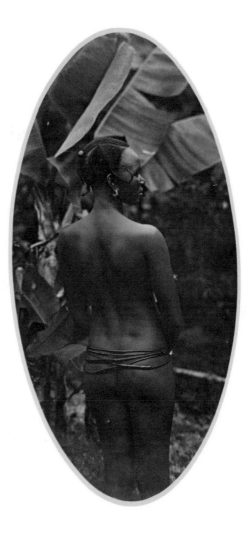

ACKNOWLEDGMENTS

THANKS TO, more than anyone, my children, Ephrem and Shalom, for their irrepressible selves and for the creativity and clatter always present in the background. I love you so much. And Betsy and Donald McKinley, always.

Nancy Miller, my editor, has been a faithful, lovely friend to me and this book; my longtime agent, Charlotte Sheedy, has my adoration always. I couldn't have done this without their support, and that of Laura Phillips and Elizabeth Ellis of Bloomsbury—brilliant shepherds.

Thank you to Aunty Koramaa, my forever muse. And to Lady Diana, Aunty Lady, Auntie Mercy, Adjoa Malaika, and all of the Alhajas, Sisters, and Aunties from the many places in which I traveled and lived for a time who have inspired this work and shared their knowledge, their opinions, their photos, and their cloth boxes.

One of my dreams for The McKinley Collection is that the archive will become "activated," in art world parlance—meaning the photos will not rest as private art objects, but become part of public realms and the base of collaborative works with others, particularly African women artists. Frida Orupabo's collages are a dream. Truly no words for you, Frida.

I relied on fellow collectors, artists, conservators, and many scholars of no institutional home for support and vast fashion, photographic, and historical knowledge: Aladji Adama Sylla, James Barnor, Jonna Twigg, Peter Mustardo, Ibrahima Thiam, Steven Dubin, Eniola Dawodu, Alhaji Kebbe, Kojo Volta, Kwasi Adu-Agyei, Paul Ninson, Sabine Bolk, Kati Torda, and especially Duncan Clarke. Thank you, too, Júlio César, for the constant inspiration of your studio.

Kiara Kerina-Rendina and Sadie Rain Hope-Gund were essential in helping to catalog and prepare the images for publication. Zalika Azim assisted

with crucial research in the book's early stages.

From fall 2018 to spring 2019, United Photo Industries (UPI) in DUMBO, Brooklyn, New York, hosted the exhibition *AUNTY! African Women in the Frame, 1870 to the Present*, curated from images in The McKinley Collection by myself and Laylah Amatullah Barrayn. The curatorial project and all of the ensuing conversations with viewers and those who wrote about it deeply informed the development of this book. Enormous thanks to Laura Roumanos, Sam Barzilay, and Dave Shelley of UPI, for their generosity and vision.

Finally, special love for Janka Nabay (1964–2018), the Sierra Leonean *bubu* music superstar who was also a devoted historian. Our conversations and his wide-open friendship—not to mention his song "Eh Congo" (2010)—has an imprint on so much of this book.

BIBLIOGRAPHY

Byfield, Judith. "'Unwrapping' Nationalism: Dress, Gender, and Nationalist Discourse in Colonial Lagos." Discussion Papers in the African Humanities, African Studies Center, Boston University, AH, Number 30, 2000.

Diawara, Manthia. *The 1960s in Bamako: Malick Sidibé and James Brown.* Paper number 11, The Andy Warhol Foundation for the Visual Arts— Paper Series on the Arts, Culture and Society, New York, NY, 2001.

Eicher, Joanne B., and Doran H. Ross, eds. *Encyclopedia of World Dress and Fashion*, Vol. 1, *Africa.* Oxford and New York: Oxford University Press, 2010.

Graham-Stewart, Michael, and Francis McWhannell. *Broad Sunlight: Early West African Photography*, London: Michael Graham-Stewart Publishers, 2020.

Koné, Barthelely, and Mamadou Koné. *Traditional and Modern Hairstyles of Mali.* Paris: Editions Delroisse, 1970.

Kriger, Colleen E. *Cloth in West African History.* New York: Altamira/Rowman & Littlefield, 2006.

Kroese, Dr. W. T. *The Origin of the Wax Block Prints on the Coast of West Africa.* Hengelo, Netherlands: N.V. Uitgeverij Smit, 1976.

Maples, Amanda M., Marian Ashby Johnson, and Kevin D. Dumouchelle. *Good As Gold: Fashioning Senegalese Women*. Washington, D.C.: Smithsonian National Museum of African Art, 2018. Exhibition catalog.

Paoletti, Giulia. "Early Histories of Photography in West Africa (1860–1910)." In *Heilbrunn Timeline of Art History*. New York: The Metropolitan Museum of Art, 2000–. www.metmuseum.org/toah/hd_ephwa.htm (March 2017).

Perbi, Akosua Adoma. *A History of Indigenous Slavery in Ghana from the 15th to the 19th Century*. Legon-Accra, Ghana: Sub-Saharan Publishers, 2004.

Saint-Léon, Pascal Martin, N'Goné Fall, and Frédérique Chapuis. *Anthology of African and Indian Ocean Photography*. Paris: Editions Revue Noire, 1999.

van Koert, Robin. *Dutch Wax Design Technology from Helmond to West Africa: Uniwax and GTP in Post-Colonial Côte d'Ivoire and Ghana*. Eindhoven, Netherlands: Stichting Afrikaanse Dutch Wax, 2007.

ADDITIONAL IMAGE CREDITS

PAGES 34–35:

Untitled, 1900
Dunau (?)/Lumière Society · Senegal

PAGE 40 (*left to right, top to bottom*):

Wolof Lady, Thiés, c. 1900
Hartmann, ed. · Senegal

A Nioro (Soudan)—Wife of a Wolof Trader, c. 1910
Unknown · Mali

Senegalese Family, Dakar
Unknown · Senegal

Wolof Women (Occidental Africa)
Collection Générale de L'A.O.F. Fortier,
Dakar · Senegal

PAGE 41:

Untitled, 1926
Unknown · Senegal

PAGE 42 (*left to right, top to bottom*):

Untitled, 1939–45
Collection Aladji Adama Sylla · Senegal

Pinda, Saint-Louis, 1925
Unknown · Senegal

Type of Wolof Woman, 1924
Unknown · Saint-Louis, Senegal

A Guernete, c. 1900
C. L. Albert · Saint-Louis, Senegal

PAGE 43 (*left to right, top to bottom*):

Wolof Woman
Albaret, ed., Dakar · Senegal

Two Fiancés, Thiés
Hartmann ed., Thiés · Senegal

Wolof Women, Thiés, undated
Cliché E. H., Thiés · Senegal

Wolof Women, Thiés, c. 1930
Cliché E. H., Thiés · Senegal

PAGE 44 (*left to right, top to bottom*):

Type of Young Mother from Conakry, c. 1910
Collection de la Guinée Français,
A. James · Guinea

Sousou Woman, 191?
A. James · Guinea

Kade-Fulani Women, c. 1914
A. James · Guinea

Sousou Woman, Conakry, c. 1908
A. James · Guinea

PAGE 45 (*left to right, top to bottom*):

Young Sousou Girls, c. 1914
A. James · Guinea

An Elegant Sousou Woman, Conakry
Collection de la Guinée Français,
A. James · Guinea

A Sousou Woman, Conakry
A. James · Guinea

*A Baga Woman in Festival
Costume, Conakry,* Undated
A. James, Collection de la
Guinée Français

PAGE 46 (*left to right, top to bottom*):

An Elegant, Conakry, c. 1910
A. James · Guinea

*Type of Sousou Trader of Conakry (French
Guinea) and His Wife,* c. 1910
A. James, Collection de la Guinée
Français - Conakry

Sousou Girl, Conakry, c. 1913
A. James · Guinea

Sousou Type, c. 1913
Unknown · Guinea

PAGE 47 (*top to bottom*):

Group of Circoncis, *Conakry,* undated
A. Albaret-Dakar · Guinea

Sousou Women, Conakry, undated
A. Albaret-Dakar · Guinea

PERMISSIONS

All images property of The McKinley Collection. Thank you to the following artists and their galleries, who own the copyright to select works:

Barnor, James, *Eva, London,* c. 1965. Copyright © James Barnor, courtesy of the artist and Autograph, London.

Keïta, Seydou, *Untitled,* 1952, 2001 and *Untitled #460,* 1956–57. Copyright Seydou Keïta/SKPE—Courtesy CAAC—The Pigozzi Collection.

Photo © Abdourahmane Sakaly, *A Yé-Yé Girl in Bamako,* Mali, c. 1965. Courtesy of the Estate of Abdourahmane Sakaly, Bamako, Mali, and Revue Noire, Paris.

Sidibé, Malick, *Christmas Eve (Happy Club), 1963; New Year's Eve, 1969; Femme peule du Niger,* 1970. Copyright Estate Malick Sidibé—Courtesy MAGNIN-A, Paris.

The author is grateful for permission to reprint the following images:

Carved stone sewing machine, Mboma, Democratic Republic of Congo, nineteenth century, copyright Dick Beaulieux, Ethnic Art and Culture, Hong Kong.

Untitled images of African textiles copyright Duncan Clarke, Adire African Textiles, London, and the collection of the Author.

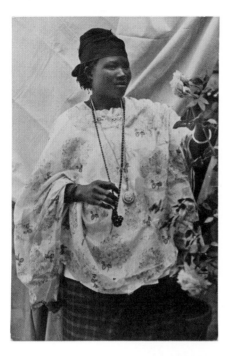
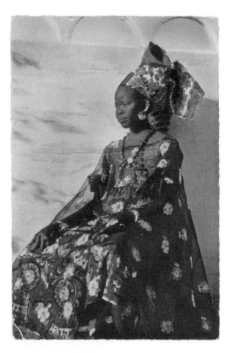
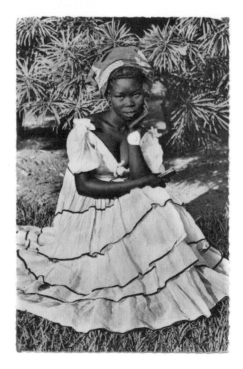

INDEX

Note: Page numbers in *italics* indicate photographs and captions.

American influences in Ghana, 154, 166, 180, *181*

bourgeois fashions, xxii, 6, 110

and colonial tropes in photography, 32

and *Dirianke*, 20, *21*

European influences, 6, 37, 58, 62–63, 104, 112

and fancy prints, 104, *107*

French fashion, 20, 78, *79*, 80, *81*, 122

and impact of early African photographers, 4

and Keïta and Sidibé's photography, 3

and post-Independence-era photography, 166

and Safieddine, 162

and sculptural clothing, 86, *87*

femme de dos, 109, *111*, *113*, *115*, 144, *146*, *151*

fetish girls and fetishized nudity

and captive girls, 142, *143*

and colonial-era photography, 31, 64

and colonial power imbalance, 109, 130

and *femme de dos*, 109, *111*, *113*, *115*, 144, *146*, *151*

and Krobo women, 138, *140*, 176, *177*

and skin decoration, 110, *111*, *113*

foreign aid to African nations, 178

formal photography, xiii, 4. *See also* family portraits and albums

Fortier, Francois-Edmond, 38, *40*

French Chamber of Deputies, xx

French fashion, 20, 78, *79*, 80, *81*, 122

French Jardin d'Acclimatation, 58

Fulani culture, 18, *44*, 72, *73*, 127, *172*, *173*

funerals and burial practices, *xx*, 37, 78, 92, 96, 104

fur, 176, *177*

Ga people, 176, *177*

Gagosian Gallery, 3

Gaye, Meïssa, 12

gele, 62

gender roles and norms

fetishized nudity, 109. See also *femme de dos*

and indigo trade, 36–38

and the *iro*, 62

and photographic exotica, 31–32

and significance of cloth in West Africa, 95, 166

and women fabric traders, 22, 94, *95*, 96, *97*, 114, *115*

gender violence, xxii

Ghana and Ghanaian culture

and colonial-era photography, 86, *87*

and colonial-era trade, 4–5

and economics of decolonization, 153–54

and Fanti fashions, 14, 86, *87*, 101, 114, *115*

and first African women photographers, xxii

and Independence-era fashion, 153–54, 160, 166, *175*, 176, *177*

Independence-era humanitarian
aid, 174, 178
and Java cloth trade, 102
and Krobo culture, 138, *140*, 176,
177
and sewing, xviii
social significance of cloth in, 96
and transatlantic slave trade, 56
Ghana Pavilion, Venice Biennale,
xxii
gifting of portraits, 4
glass beads, 56, 57
gold, 4–5, 37, 38, 56, 100, 130
Gold Coast. *See* Ghana and Ghana-
ian culture
Gorée Island, 22
gourmettes, 20
Grand Dakar sleeves, 8, *9*
Great Migration, xviii
Greaves, James, 62–63, *63*
Guggenheim Museum, 3
guinea cloth, 48
Guinea Coast, 56
Guinea Studios, *42–45*, 127
guipure lace, 112

hairstyles
Afros, 12, 166, 167–69, 172
as age marker, 10, *11*, 76, *77*
and American pop influences, 12,
13
and "Been To," 14, *15*
and "colonial studio" tropes, 32
and Fanti culture, 14, 114
and Fanti fashions, 114, *115*

and *femme de dos*, 109, *111*, *113*
and Independence-era fashion,
166, *167–69*
and indigo dyes, 36–37
and marriage practices, 76
Versailles style, 8, *9*
Western cultural influences, 166
hajj, 5, 70, *71*
hand-painted fabrics, 88, *89*
Hartmann, ed., *40*, *43*
Haute Volta, 38
headscarves and head coverings
and colonial-era photography,
49–51, *55*, *59–61*, 64–68, *65*, *69*,
72, *73*, *97–99*, *101*, *103*, *105*, *107*, *109*
duku, 166, *171*
and *femme de dos*, *149*
and indigo cloth, 38
and Indonesian batiks, *103*
and Keïta and Sidibé's photogra-
phy, 6, *7*, *9*
and Krobo culture, *140*
and Mama Cassett's photogra-
phy, *28*
and post-Independence-era
photography, *171*, *179*, *181*
and private photography, 128, *129*
and women traders, *93*
and work of first African
photographers, xxii, xxiv
heirlooms, photos as, xiii-xiv, 37
Helmond, The Netherlands, 92,
94, 102
hemlines, 154
henna, 110
"heritage" products, 92

locations of photographic studios,
xxiv

"lookbook" term, xiii

Lumpkin, Carrie, xxii

luxury products, 4. *See also* class
divisions and hierarchies;
prestige items

Mali
American cultural influences, 12
and de Gaulle–style headscarves,
6
and Independence era, 8, 12, 16,
153
and indigo cloth, 38
socialist military government, 16

Mama Benz, 94, *93*, 94, *95*

"mammy" figures, xxii

Mande culture, 37

market women, 92, *93*

marriage practices, xx, 4, 31, 37, 38,
64, 66, 76, 100

military rule, 154

miniskirts, 154

missionaries, xx-xxi, 38, 62, 114, 160

mixed-race population, xxii, 74

modernism/modernity, xxii, xxiv,
6, 26, *27*, 160, 174

modes and tropes of photography,
31–33, 58

Mrs. Felicia Abban's Day and Night
Quality Art Studio, xxii, *169*

Musée de la Mer, 22

Muslims and Islamic influences
and American cultural influences,

12
and colonial-era photography, 33,
37, 80
and indigo cloth, 37
and Mali's military government,
16
and post-Independence-era
photography, 176, *177*
and religious taboos, 112
and subjects of early African
photographers, 12, *13*
Sufi Muslims, 74

My Husband Is Worthy, 92, *93*

Napoleon III, 58

Niger, 18, *19*, 48, 153

Nigeria, xx, 62–63, 109, 153

Nkrumah, Kwame, xxii, 153–54

No More Velvet (cloth design), 88,
89

nudity
and colonial-era photography,
64–66
and colonial power imbalance,
109, 130
and *femme de dos*, 109, 144,
145–151
and private photography, *121*, 125,
126–29, 131, *133–35*, 137
skin decoration featured in
photographs, 110, *111*, *113*, *135*,
137
See also fetish girls and fetishized
nudity

A NOTE ON THE AUTHOR

CATHERINE E. MCKINLEY is a curator and writer whose books include the critically acclaimed *Indigo*, a journey along the ancient indigo trade routes in West Africa, and *The Book of Sarahs*, a memoir about growing up Black and Jewish in the 1960s to '80s. She's taught creative nonfiction writing at Sarah Lawrence College and Columbia University. The McKinley Collection, featured here, is a personal archive representing African photographies from 1870 through the present. She lives in New York City.